1492

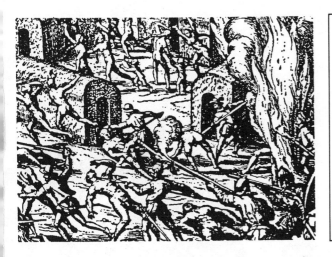

sav age (sav'ij), 1. wild: *He likes savage mountain scenery.* 2. not civilized; barbarous: *Gaudy colors please a savage taste.'*. 3. person living somewhat as wild animals do. 4. fierce; cruel; ready to fight: *The savage lion attacked the hunter.* 5. a fierce, brutal, or cruel person. *adj., n.* 5
sav age ly (sav'ij li), in a savage manner. *adv.*
sav age ness (sav'ij nis), 1. wildness: *the savageness of a jungle scene.* 2. savage or uncivilized condition: *the savageness of some African tribes.* 3. cruelty; fierceness. *n.*
sav age ry (sav'ij ri), wildness; savage state; cruelty. *n., pl.* sav age ries.

Ken Crane's
FINAL DAY!
COLUMBUS SALE
"DISCOVER" THE KEN CRANE DIFFERENCE

What Is It Like to Be *Discovered*?

by Deborah Small with Maggie Jaffe

MR MONTHLY REVIEW PRESS • New York

Library of Congress Cataloging-in-Publication Data

Small, Deborah, 1948-
 1492 : What is it like to be discovered? / by Deborah Small with
Maggie Jaffe.
 p. cm
 ISBN 0-85345-836-7 : $15.00
 1. Small, Deborah, 1948- . 2. Artists' books—United States.
I. Jaffe, Maggie. II. Title.
 N7433.4.S43A4 1991 91-29044
 700' .92—dc20 CIP

Monthly Review Press
122 West 27th Street
New York, NY 10001

Printed on recycled paper
Manufactured in the United States of America

10 9 8 7 6 5 4 3 2

This book is dedicated to Andrea Hattersley

This book project has grown out of many conversations between Deborah Small and Maggie Jaffe over the last five years. Maggie Jaffe wrote the poems, "The Opening," "Queen Anacaona," and "Father Bartolomé." She also assembled the bibliography. Unattributed texts, artwork, and the layout of the book are by Deborah Small. She developed the texts and images in conjunction with three art exhibitions: "1492" in 1986, "New World [Women]" in 1989, and "Empire/Élan/Ecstasy" in 1990.

We would like to thank Harold Jaffe, Carla Kirkwood, Gail Shatsky, Louis Hock, James Luna, Karla Donahue, Mary Williams, Mark Baddley, James Scully, Hans Koning, and Richard Drinnon.

Special thanks to David Avalos, Anna O'Cain, and Elizabeth Sisco for their advice on all aspects of the project, to Robert McDonell and William Weeks for their ideas and editorial assistance, and to our editor, Susan Lowes, at Monthly Review Press. Thanks also to the Warren College Writing Program at the University of California, San Diego, for its supportive community of friends and scholars.

Many of the images used in this book have been adapted from sixteenth-century engravings by Theodore de Bry, whose work documents the devastation of the Indies during the early years of European colonization. The engravings were first published in de Bry's *Great Voyages* to accompany Girolamo Benzoni's narrative account of the "New World" and to illustrate Bartolomé de Las Casas's *Narratio Regionum*. Other images are adapted from the sixteenth-century woodcuts that illustrate Amerigo Vespucci's accounts of his voyages to the "New World." Contemporary images are adapted from children's books, history textbooks, and films.

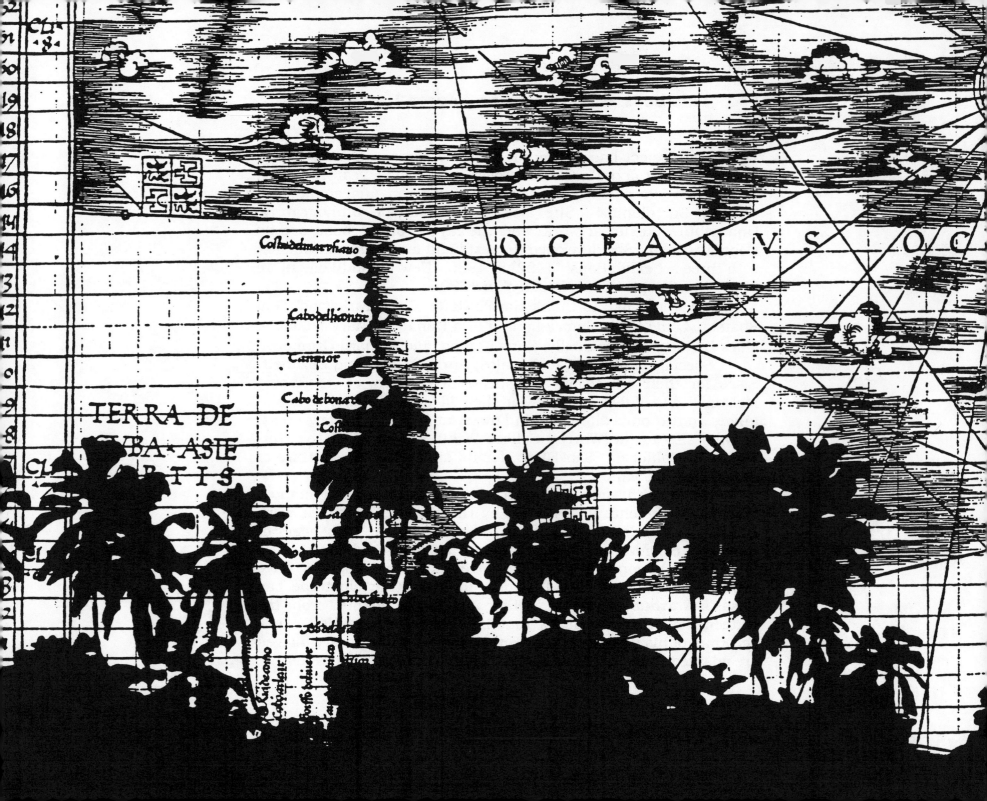

dis•cov•er

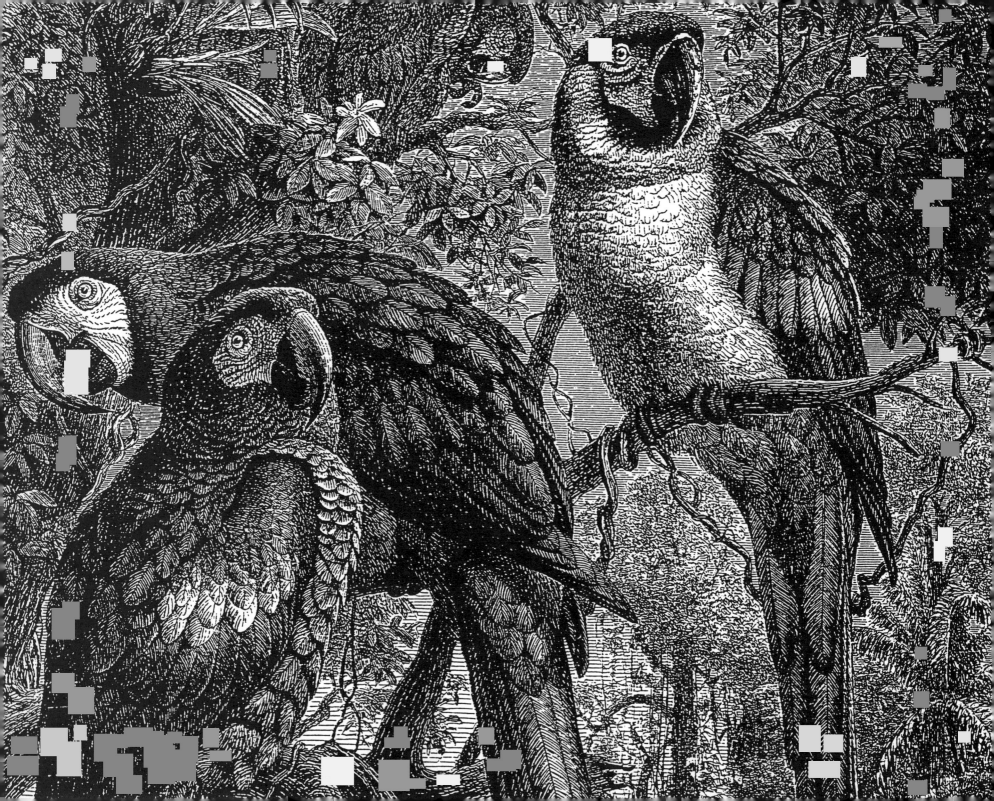

Language is the perfect instrument of **Empire**.

From the *Gramática,* 1492,
by Antonio de Nebrija

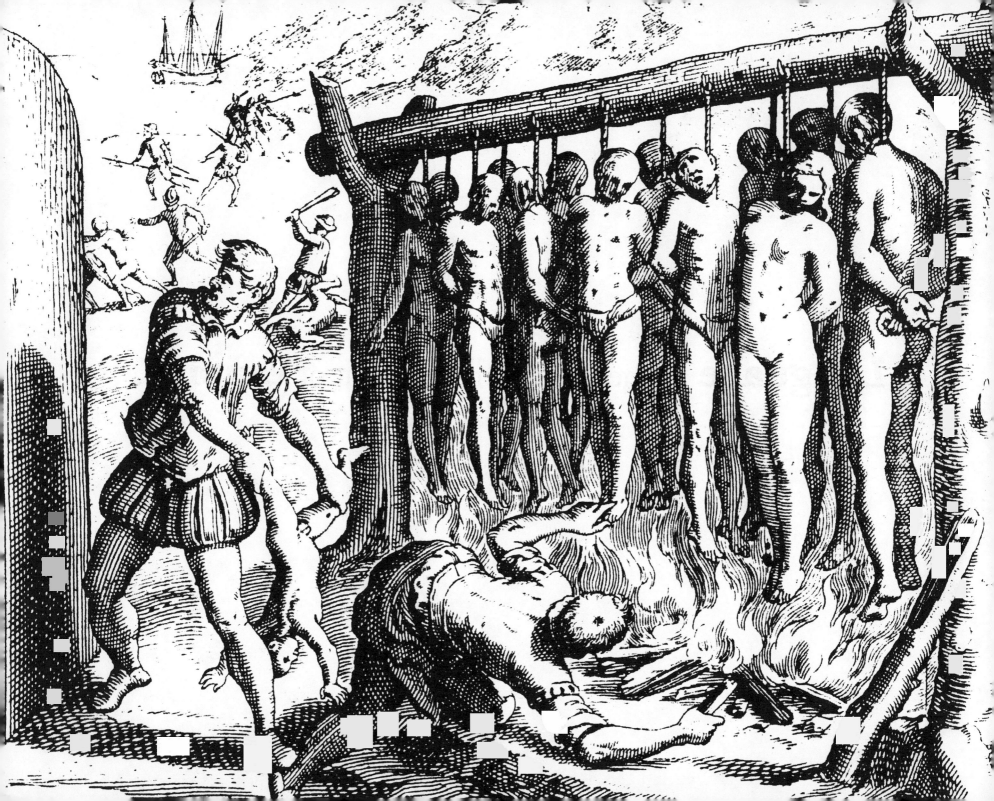

THE OPENING

Maggie Jaffe

Black sand
white foam
(almost gold!)
in violent light.

Three ships:
a red-throated
songbird alerts them to land.
 It is the slit-
 throat
bird.

There they stand
naked.
Two men, three women,
one child left on shore:
crow-black hair,
skin the color of fired copper.

First a shot.
Their entrails stream
away like frightened fish.

The earth
they call mother
grown malignant,
strange.

They want gold
but there isn't any gold
just the sun
which might have been
enough.

For gold they
hack off their hands,
hang them from
Cassava trees
thirteen in number
 symbolizing Apostles
 and the Lord in his mercy.

Within twenty-five years
not one Arawak survives.

...felicita del ~Re~ e de la ~Regina~ de Spagna. Z...

...r le cose mirabile cbe in essa se contengono bau...

...ta de bispana in nostra Italica lengua : τ uolendol...

...seruirne alcbuni mei amici:cbe cum grande in...

...o omandauano:como ancbora per fare cosa grat...

...τ sono desiderosi de cose noue:τ degne da esser...

...Zbo dedicata a tua Magnificentia la quale sci...

...istorie degne:τ presertim noue:quale questa mar...

...a uita. Poi ancbora per monstrarli lamore mio...

...si per li beneficij soi in me como per le grande v...

...ornatissima. Quale bistoria se piu lōga fosse: pi...

...ei a tua Magnificentia dedicata. Ma siamilic...

...n quello sicto. Rerum τ alijs lacte rustici:mul...

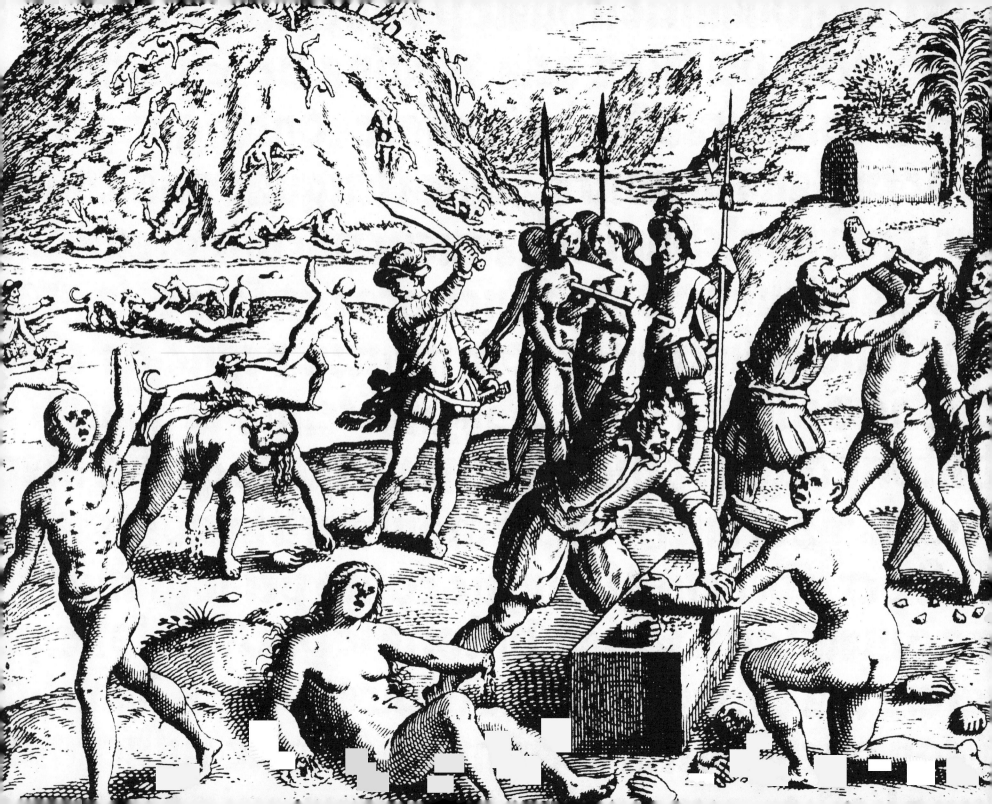

It is **1492.** Columbus sails the ocean blue. In the "New World," vultures roost in the tall trees, scan the horizon, wait.

It is **1451.** Christopher Columbus and Queen Isabella of Spain are born. Five years later, "Halley's" comet streaks across the sky.

It is **1456.** Tainos in the "New World" watch the comet. For Europeans, the comet forebodes plague, famine, disaster.

It is **1492.** Jews are given an official ultimatum: conversion or expulsion from Spain. The same year the Moors are defeated. They too are driven from Spain.

It is **1492.** Columbus sails into the unknown.

Colón descubrió el mundo nuevo.
Colón descubrió el mundo nuevo.
Colón descubrió el mundo nuevo.

It is **1991.** The same words chalked across the blackboard in a schoolroom on a Caribbean island. Two instructors from Southern California teach island children the important lesson. *En Español.* Tomorrow, the English translation: **Columbus dis•cov•ers America.**

It is **1492.** Columbus sails the ocean blue. On Christmas Day, the *Santa María* wrecks off the country now called "Haiti."

The Niña, the Pinta, the Santa María
were sailing vessels three.
They hoisted their sails
at the harbor of Palos
to cross the western sea.

It is **1493.** Columbus sails to the "New World" on this Second Voyage. Leonardo da Vinci begins his *The Last Supper*, Hieronymus Bosch *The Garden of Earthly Delights*.

It is **1501.** Columbus returns to the "New World" convinced that this time he has found the earthly paradise. The same year Albrecht Dürer completes his woodcut, *The Four Horsemen of the Apocalypse*, his allegorical vision of Death, Famine, War, and Pestilence. Forty years later Bartolomé de Las Casas, Dominican friar, records a Dürer-like apocalypse in his *Brief Account of the Devastation of the Indies*, which documents the extermination of Indians in the "New World." Later, engraver Theodore de Bry will illustrate Las Casas's text. De Bry portrays the conquistadors "savagely" chopping off the hands of Tainos who have not found their quota of gold.

It is **1503.** Dürer paints *The Great Piece of Turf*, a watercolor not of the "exotica" of the "New World," but a precise and carefully rendered depiction of flora in the "Old World."

It is **1493.** Columbus is not a painter but an amateur naturalist. He takes "specimens"

rather than watercolors back to Spain after his first voyage. Among his collection of trees, plants, and parrots, he includes six live Tainos. He proudly presents his collection to Queen Isabella and King Ferdinand.

It is 1503. Leonardo completes his *Mona Lisa.* Columbus embarks on his final voyage to the "New World." The pocket handkerchief comes into widespread use.

It is 1494. Columbus and company gather green wood to place under the feet of Tainos. The conquistadors string them up in groups of thirteen. The burning is slow, methodical, torturous.

"The weather is like April in Andalusia," Columbus notes in his journal.

Extermination is a thirteen-letter word. Groups of thirteen Tainos are exterminated "in memory of our Redeemer and His twelve Apostles." Leonardo's *Last Supper* depicts the same thirteen.

"All night we heard birds passing," Columbus writes.

It is 1503. Religious iconography is absent from Dürer's *The Great Piece of Turf.*

"Let us in the name of the Holy Trinity go on sending all the slaves that can be sold," Columbus tells his sovereigns.

In the name of the **FATHER**
In the name of the **SON**
In the name of the **GHOST**

It is 1500. Amerigo Vespucci and company, according to some accounts, "discover" the mouth of the Amazon River.

It is 1502. "Gold is most excellent," Columbus writes. "He who possesses it does what he will in the world, even to the point of sending souls to Paradise."

It is 1507. Martin Waldseemüller proposes that the "New World" be designated *America* after Amerigo Vespucci. Columbus has been dead for two years.

It is October 12, 1492. Columbus Day. The familiar "V" of vulture wings in the Caribbean sky. The Indians, according to Columbus, are friendly, generous, peaceful, naked. Noble savages.

What is it like to be **discovered**?

It is 1492. Columbus sails the ocean blue. Piero della Francesca, who writes the first treatise on single point perspective, dies.

Leonardo, using one of his corpses as a model, sketches the carpals, metacarpals, and phalanges of the hand. Many people oppose dissection of the human body for fear of the consequences upon resurrection.

In a de Bry engraving, a Taino sits on the ground, her arms mutilated stumps, her mouth gaping. Another Taino, forearm upon the chopping block, looks directly at us. Hands too numerous to count surround him as he kneels before the conquistador.

God! Gold! Glory!

In Bosch's triptych, *The Garden of Earthly Delights*, the right panel engulfs hapless victims in fire and flames. Not the terrestrial paradise but hell on earth.

It is 1519. Leonardo, artist, anatomist, Renaissance man, dies. The same year Hernán Cortés, Reconnaissance conquistador, is received by Montezuma at Tenochtitlán. The year Sebastiano del Piombo paints his posthumous portrait of Columbus that hangs in the Metropolitan Museum of Art in New York City. Columbus, imperious, stares directly at the viewer.

The "New World" vulture first removes the eyeballs from a carcass, then tears through the skin to lay bare the muscle underneath.

It is 1496. After only four years, half the native population of Hispaniola is dead. Columbus and company have transformed the "New World" into a hell on earth.

Gold! Glory! God!

It is 1516. Sir Thomas More's *Utopia* is published, inspired in part by enthusiastic accounts of the "New World."

It is 1492. "Our Lord in his goodness guide me that I may find this gold," Columbus writes.

The mathematical golden rule is the rule of three, or rule of proportion. The Christian golden rule is to do unto others as you would have them do unto you.

Gold! Gold! Gold!

It is 1531. "Halley's" comet returns. The same year the complete works of Aristotle are published for the first time. Some men are fit only for subjugation as slaves, Aristotle tells us. By 1531, almost the entire population of Tainos has been decimated. Burning, hanging, starvation, disease.

It is 1492. "The air is soft as April in Seville," Columbus records in his notebook.

It is 1517. Las Casas protests the enslavement of Indians in the "New World." One year later, spectacles for the shortsighted are invented.

It is 1547. Columbus's portrait painter Sebastiano dies in Rome. Eighty-year-old Las Casas leaves the "New World" for the last time to return to Spain, where he will concentrate on working on behalf of the Indians.

It is 1492. Columbus sails the ocean blue. He disembarks on the island of Guanahani, plants a cross, renames the island San Salvador.

In the name of the **FATHER.**
In the name of the **SON.**

It is 1986. In Southern California, "Halley's" comet is difficult to see with the unaided eye. In six years, the 500th anniversary of the "discovery" of America will be celebrated. The star with the prodigious tail will be long gone.

It is 1550. In Vallodolid, Las Casas confronts Juan Ginés de Sepúlveda, foremost defender of the Spanish conquest of the "New World." Sepúlveda quotes Aristotle to justify the conquest of Indians: "They have no souls. . . ."

It is 1503. The Indians, according to Columbus, are unfriendly, cruel, hostile. Savage savages.

It is 1566. Las Casas dies while working on his final manuscript, *About the Sixteen Remedies Against the Plague which has Exterminated the Indians.* "Las Casas Day" is not celebrated in the United States. Las Casas did not discover America. Perhaps he was the first to "discover" Americans.

One little two little three little Indians . . .

It is 1968. Quang Ngai is "Indian Country." In Vietnam, the only good ____ is a dead ___.

In the second and third grades, children first learn about Columbus. The same age little girls become Brownies. Brownies learn to use green wood sticks to roast marshmallows. When the marshmallows are golden brown, the girls place them between two graham crackers lined with chocolate bars. The treat is called "s'mores."

Columbus and company use green wood to roast Tainos and Caribs. Neither Brownies nor Cub Scouts know about the roasting of Indians. They know the *Niña*, the *Pinta*, the *Santa María*. They know 1492. They know less, not more.

Ten little eleven little twelve little Indians

One Redeemer + Twelve Apostles = Thirteen Indians.

It is 1492. Columbus sails the ocean blue.

Be Discoverers: the first of three Brownie B's.

It is 1498. Leonardo completes *The Last Supper*. Leonardo's masterpiece has recently been carefully restored.

In *Man in the Holocene*, Max Frisch writes that "What would be bad would be losing one's memory." Worse still is a society's collective amnesia of its history.

The *Niña*. The *Pinta*. The *Santa María*.

Columbus's favorite book is *Imago Mundi* by Pierre d'Ailly. Image of the World.

Go West, Young Man!

It is 1985. I discover Simonetta Vespucci, the second European female protagonist in my story, admired by the prime movers of her century. According to some historians, she appears five times in Botticelli's painting, *Primavera.* She is, of course, very beautiful. She is the cousin of Amerigo Vespucci. It is Amerigo's name that is printed on maps of the western hemisphere: AMERICA.

It is 1492. Columbus sails the ocean blue. Antonio de Nebrija presents the *Gramática,* the first grammar of a European modern language, to Queen Isabella. "But what is it for?" Isabella asks. "Your Majesty, language is the perfect instrument of Empire," he replies.

It is 1573. King Philip II of Spain declares that the *conquest* will be referred to as the *pacification.*

The cutting edge of language is a knife.

In fourteen hundred ninety-two, Columbus sails the ocean blue.

It is 1493. Columbus sets sail with 17 ships, 1500 men, and 20 purebred mastiffs and greyhounds for his Second Voyage to the "New World." The native dogs do not bark. *Perros mudos.* Mute dogs. They learn to bark, however, after coming into contact with European dogs.

The voice of the "New World" vulture is a low hiss, seldom uttered. The vulture is dependent on a discriminating sense of smell and sight. The vulture is dependent on dead flesh.

It is 1783. George Washington compares the Indian and the wolf. They are both "beasts of prey, tho' they differ in shape."

"Imagine a savage . . . "

It is 1494. Columbus discovers the island now called "Jamaica." Terrified Indians flee from soldiers and their crossbows. Dogs pursue the Indians.

". . . so many birds flocked there to scavenge that they darkened the sky."

It is 1494. Botticelli paints his *Calumny.* Leonardo puts the finishing touches on his *Madonna of the Rocks.*

It is 1495. *¡Tómalos!* Sic 'em! The first pitched battle between Europeans and Indians on the Vega Real in Hispaniola. Dogs grab the Indians by the throat, disembowel them, rip them to pieces. In the "Old World," dogs are trained to hunt wild game. In the "New World," they learn to savor human flesh.

Hail Mary, Full of Grace.

It is 1495. Columbus devises a system to extract more gold from the natives. When it becomes impossible for them to deliver, the Indians again flee into the mountains. The dogs track down the fugitives, distinguishing "pagan" from Christian trails.

Our Father, who art in Heaven.

It is 1512. "No one may beat or whip or call an Indian 'dog' or any other name unless it is his proper name." Many Spaniards refer to the Indians as "perros." Dogs. The Laws of Burgos, a set of regulations on the use of Indian labor, forbid use of the word "dog" in referring to Indians. The same year Copernicus announces that the earth revolves around the sun. Amerigo Vespucci dies.

It is 1512. The quest for gold continues. Spanish colonists on Hispaniola import African slaves to replace dead Indians. Michelangelo finishes Adam's outstretched hand on the ceiling of the Sistine Chapel. Ponce de León sets out for the Fountain of Youth.

¡Tómalos!

It is 1522. In an uprising, slaves working the sugar plantation owned by Diego Columbus kill several Spaniards. The slaves flee, young Columbus and his dogs in hot pursuit. Sic 'em!

In the name of the **FATHER.**
In the name of the **SON.**

It is 1976. General Westmoreland writes his memoirs. The canine body count in Vietnam: 36 killed in action; 153 wounded.

It is 1986. In children's history books, the words *pacification* and *extermination* do not appear in chapters about Columbus's "discovery" of America. In *The Story of Our Country*, no Tainos or Caribs are killed. Instead, the Indians are "friendly, but poor."

It is 1493. Europeans taste pineapple from the "New World" for the first time. Europeans like the taste.

It is 1991. The death by disease, starvation, and slaughter of 90 million inhabitants of the "New World" is not included in the list of the twenty most important events in American history. Or is it 70 million, as other historians claim? Or is it 6 million?

The *Niña.* The *Pinta.* The harbor of Palos.

It is 1492. Columbus "discovers" the pineapple on his first voyage to the "New World."

It is 1991. The pineapple, or fragmentation grenade, detonates in the "New World," bursting into metal fragments called shrapnel. "Halley's" comet, astronomers tell us, no longer sweeps across the smog-filled sky.

It is 1492. Columbus sails the ocean blue.

If you dis•cov•er that some among them steal, you must punish them by cutting off nose and ears, for those are parts of the Body which cannot be concealed.

Christopher Columbus, 1494

amer•i•ca

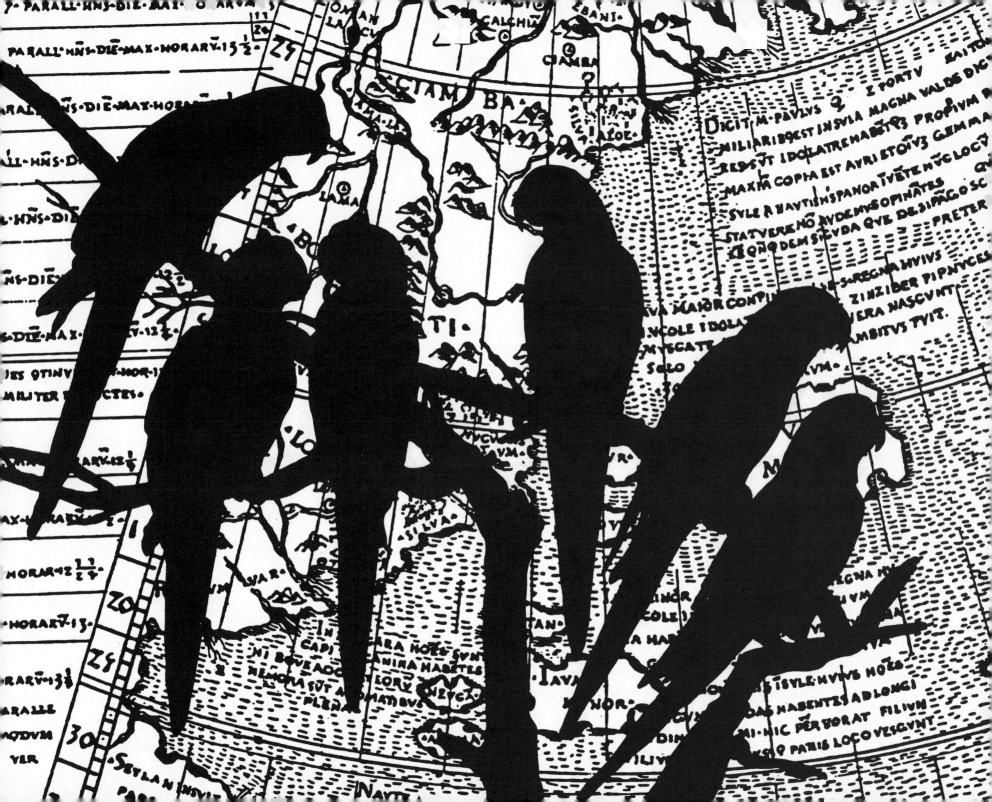

UNmapped
UNcharted
UNdiscovered
UNimagined
UNknown
UNsullied
UNspoiled
UNtouched
UNtracked
UNtrammeled
UNtraversed
UNclaimed
UNnamed
UNtamed
UNpenetrated
UNexplored
UNinhabited
UNdeveloped

UNdomesticated
UNdescribed
UNcolonized
UNmined
UNcontrolled
UNinscribed
UNmastered
UNrecorded
UNdocumented
UNcivilized
UNsuppressed
UNexploited
UNsubjected
UNsubjugated
UNsubdued
UNdominated
UNconquered
UNpossessed

Columbus sailed the ocean blue in fourteen hundred ninety two.
Columbus sailed the ocean blue in fourteen hundred ninety two.
Columbus sailed the ocean blue in fourteen hundred ninety two.
Columbus sailed the ocean blue in fourteen hundred ninety two.
Columbus sailed the ocean blue in fourteen hundred ninety two.
Columbus sailed the ocean blue in fourteen hundred ninety two.
Columbus sailed the ocean blue in fourteen hundred ninety two.
Columbus sailed the ocean blue in fourteen hundred ninety two.
Columbus sailed the ocean blue in fourteen hundred ninety two.
Columbus sailed the ocean blue in fourteen hundred ninety two.
Columbus sailed the ocean blue in fourteen hundred ninety two.
Columbus sailed the ocean blue in fourteen hundred ninety two.
Columbus sailed the ocean blue in fourteen hundred ninety two.
Columbus sailed the ocean blue in fourteen hundred ninety two.
Columbus sailed the ocean blue in fourteen hundred ninety two.
Columbus sailed the ocean blue in fourteen hundred ninety two.

They are good to be Ordered about,
to be made to Work, Plant, and do
whatever is wanted, to Build towns
and be taught to go Clothed and
accept our Customs.

Christopher Columbus, 1492

sav•age

The Indians, according to Columbus, are
 a) generous
 b) handsome
 c) intelligent
 d) friendly
 e) all of the above

The Indians, according to Columbus, are
 a) naked
 b) rude
 c) hostile
 d) savage
 e) all of the above

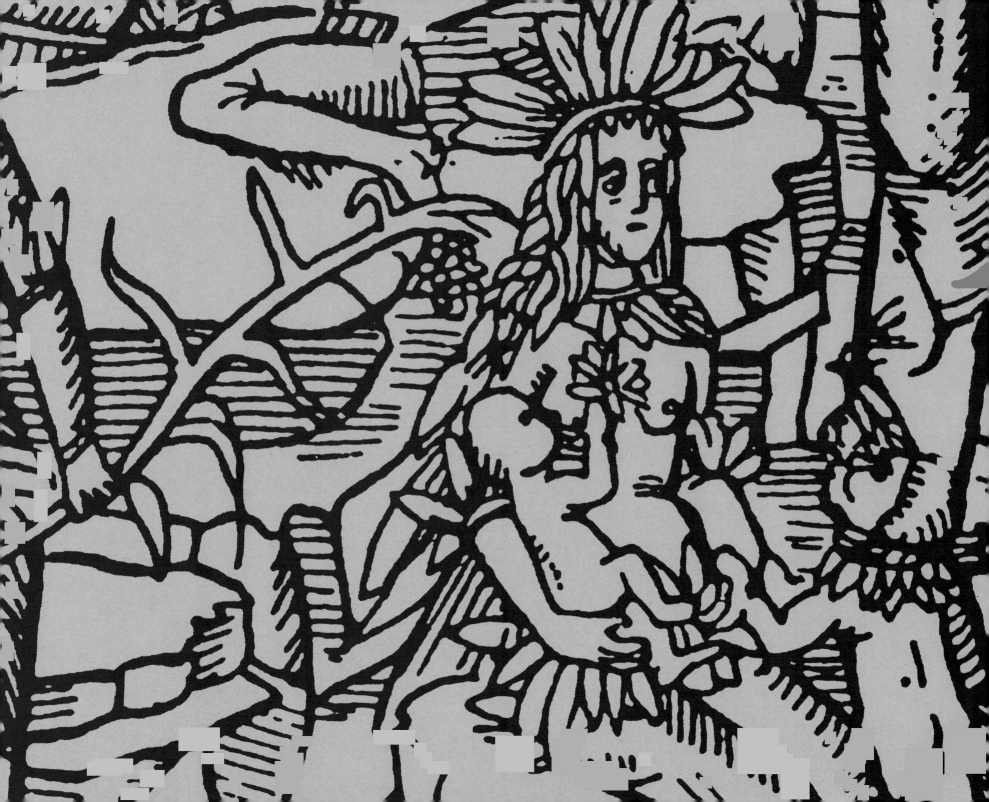

They don't wear clothes.

They don't speak English.

They don't read.

They don't use napkins.

They forget to ask permission.

They don't bathe in tubs.

They don't say grace.

They don't write.

They don't keep journals.

They don't believe in private property.

They give away their things.

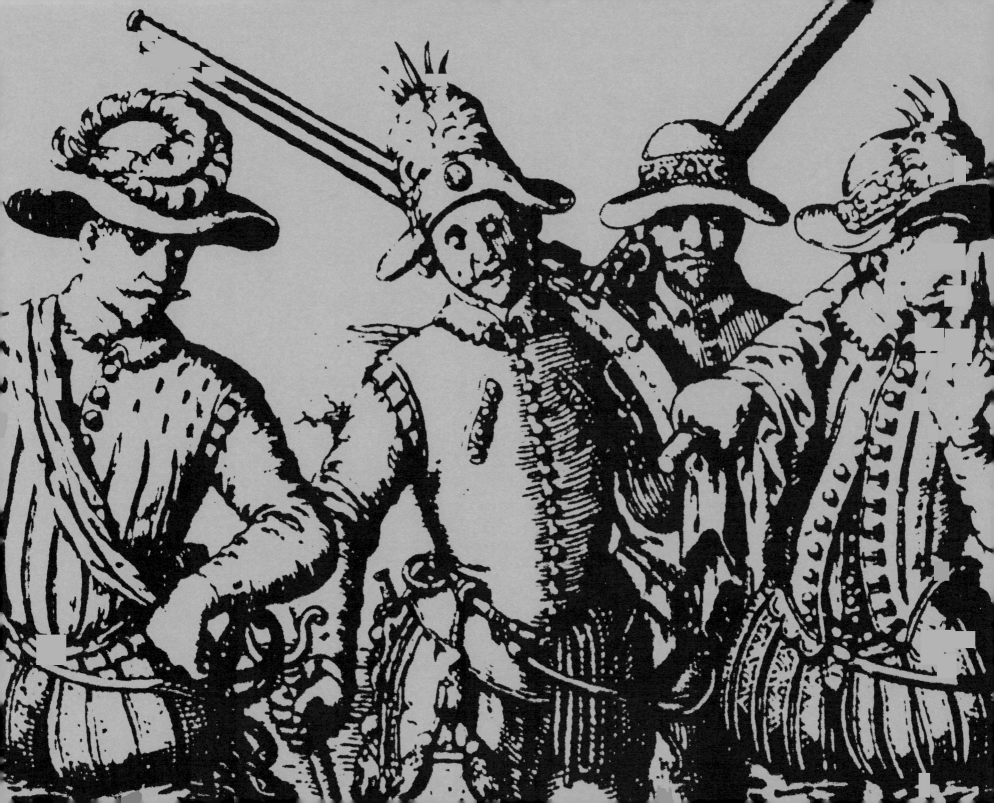

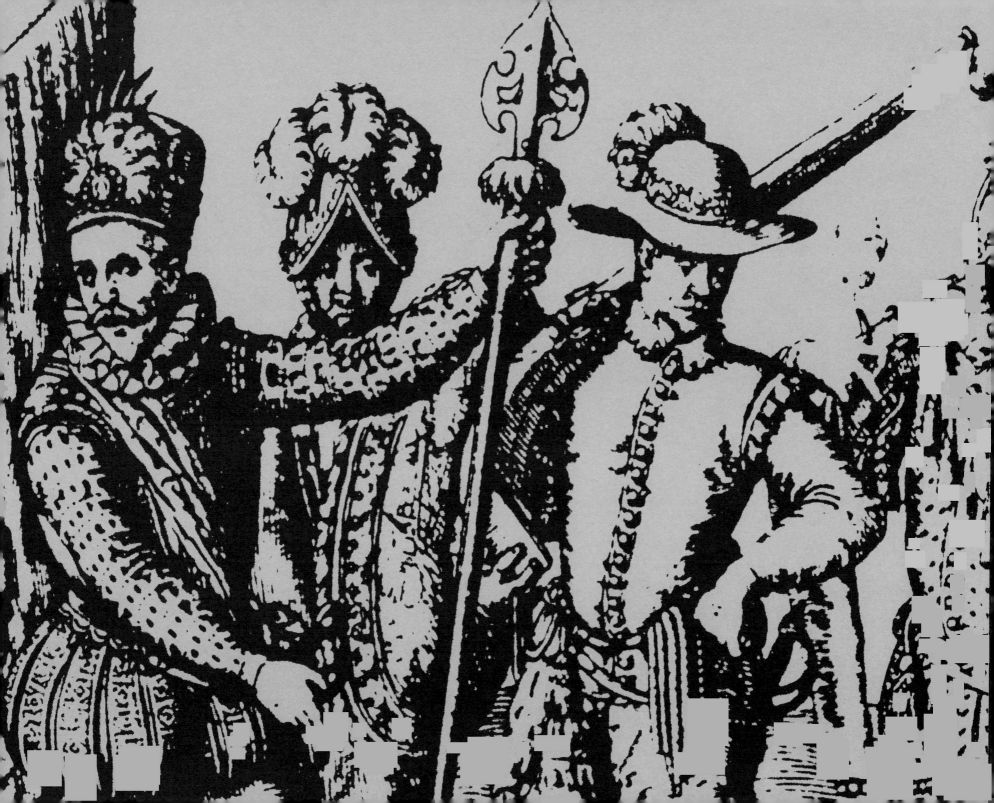

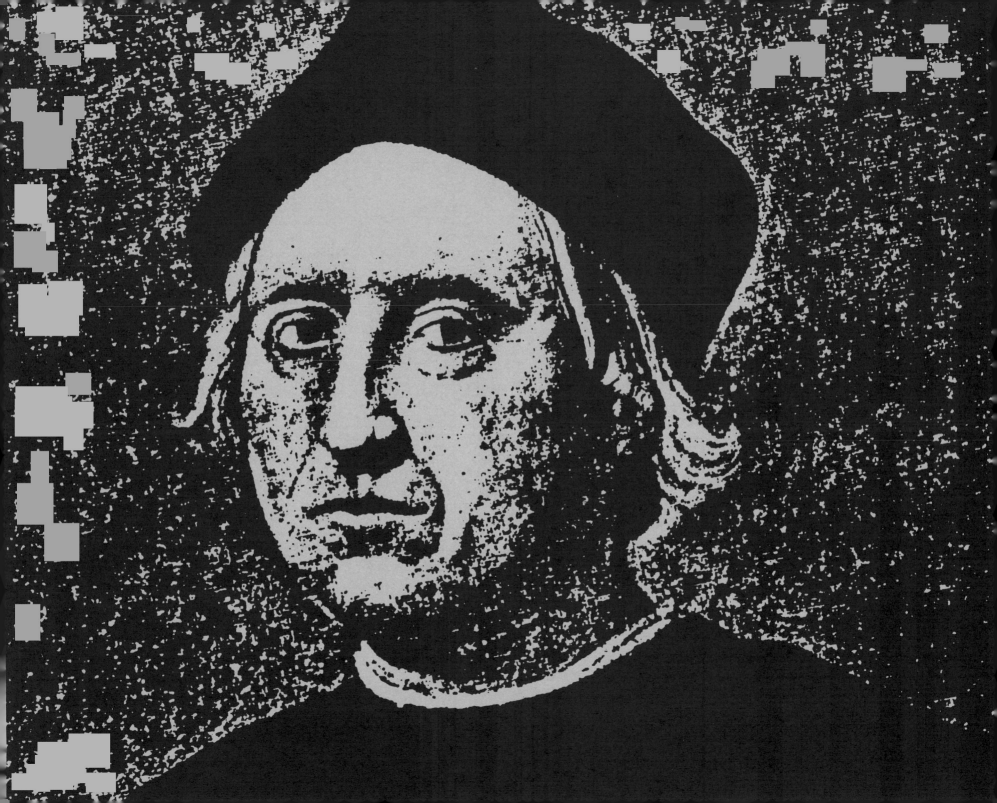

SAVAGE • SAVAGE

It's 1492.
I want to discover something.
I want to discover something in a big way.
We all do.
I want to be famous.
Everyone wants to be famous
for fifteen minutes.
I want to be famous forever.

It's 1492.
I sail the ocean blue.
Two rhymes with blue.
I gaze skyward.

I get together three ships.
The *Niña*, the *Pinta*, the *Santa María* . . .
We set sail.
We head WEST.
We always do.

We battle the elements.
The men are mutinous.
We could be struck by lightning.
I write in my journal:
April is the cruelest month.
I nail a gold doubloon to the mast.
We keep going.

The WEST is a VIRGIN.
The West is always a virgin.

¡Tierra! ¡Tierra!
Land! Land! I cry.
The future doesn't just happen.

You're right, Columbus,
the mutinous men cry.
I always am.

I discover AMERICA.

We disembark.
I sit astride a white horse.
I wear a white hat, tight boots, teflon shirt.
All conquistadors do.

We plant a few crosses.
We carry a few trinkets.
We look around for gold.

I gaze skyward.
I hold a sword in my right hand.
I grasp the banner of
my expedition in the other.
The men surround me.
Several fall on their knees, kiss the earth.

I gaze skyward.

This is MY country.

But where is the GOLD?

I see us painted in the Capitol rotunda.
Sculpted on the doors.
Modeled on the frieze.

But not yet.
There is the problem of the natives.
What is to be done about the natives.

The natives are naked.
Natives are always naked.

There is the RAW.
There is the COOKED.

The natives don't speak English.
They don't speak Spanish, German,
French, or Dutch.

The cutting edge of LANGUAGE is a knife.

Savage/savages.

But where is the GOLD?

The natives are pagans.
The natives are barbarians.
The natives are heathens.

We like to save souls.
We always do.

At first we want to convert them.
Later we don't.
We exterminate them.

We always end up exterminating the natives.
One way or another.
We can't help it.

In the name of the FATHER.
In the name of the SON.
In the name of the GHOST.

AMERICA is a VIRGIN.
I am her white knight.

We perfect our methods.
First we tread softly.
Then we use dogs.
¡Tómalos!
Sic 'em!

We dress for success:
Armor, swords, pikes, crossbows,
Rope and green wood.

We've come a long way.
It's the only way to come.

Veni, Vidi, Vici.

It's a jungle out there.

Winning is the only thing.

It's easy to burn in hell.
We burn Indians.
We string them up in groups of thirteen.
We light the fire.

We honor our Lord and His Apostles.
All thirteen of them.

Life imitates art.

Extermination is a thirteen-letter word.
The *Last Supper* is a painting.
Civilization is for the civilized.

Burn, baby, burn.

The best things about AMERICA are free:
Free markets.
Free fire zones.
Friendly fire.
Open seasons.

Nobel prizes yes.
Noble savages no.

You are free to honor me.
My self-reliance.
My persistence
My zest for life.
My feeling for beauty.

My sheer guts.

My communion with the UNknown.

Take a minute.
Gaze skyward toward Columbus Circle.
My statue throbs in the heart of America.
My monument is 39 feet tall.

Amer•i•ca is reality.

I want to be famous.
I am.

Chilcotin Gros Ventre Piegan Algonkin Bellabella Bellacoola Ojibwa Cree Dakota Haida Haisla H
ka Nootka Ottawa Squawmish Mashpee Nantucket Narragansett Niantic Nonotuc Wabaquasset C
hasset Massapequa Rockaway Seca Chattahoochee Crotoan Raritan Roanoke Secotan Shinn
nbee Woccon Seminole Calusa Pota i Miami Sauk Foxes Winnebago Onondaga Cayuga Sene
rida Nipmuc Wampenoag Squamso uset Winnecowet Massachusett oot Yanktonai Mande
kton Omaha Iowa Ponca Oglal eto a Sisseton Min ickapoo Kansa Wic
akoni Tawehash Kiowa Anad ea Missouri Tamar
ctaw Biloxi Pascagoula Chawo o Moingwena Caho
kinampo Tuskegee Com Rappahannock Ch
ckahominy Yadkin se Snake Willopah
nock Skilloot Sko tuntude Pima Pan
amook Yakima Ch Jicarilla Apache N
yenne Arapaho Ut nock Northwest Sho
tes Havasupai Ka acoola Ojibwa Cree
atsa Huron Iroquo Narragansett Niantic
aquasset Canarsee ee Crotoan Raritan
nnecock Wando Wi Foxes Winnebago Ono
eca Tuscarora On Winneco et Massachusett Pequo
dan Santee Arikara Sisseton Minniconjou Kick
Wac ge Little Osage Quapaw Mosopelea
Pawnee Oto Moing
ie Potomac Rapp
ouse Cayuse Sna
Taltushtuntude
Apache Jicarilla Apo
hoshoni Bannock Northwest Sho
th Bellabella Bellacoola Ojibwa Cree
Mashpee Nantucket Narragansett Niantic
g Secatogue Chattahoochee Crotoan Raritan
Potawatomi Miami Sauk Foxes Winnebago Ono
scot Wachuset Winnecowet Massachusett Pequo
Brule Teton Arikara Sisseton Minniconjou Kick
Nasoni Osage Little Osage Quapaw Mosopelea M
acha Caddo Nacogdoches Pawnee Oto Moing
are Shawnee Pottawatomie Potomac Rapp
ish Chelan Spokan Palouse Cayuse Sna
Wiyot Chepeneafa Taltushtuntude P
Tuscaro ueno ueno Luiseno Gabrielino Cahuilla Ju
rano Nicol umash Salinan Esselen Yokuts Costanoan
Papago Quech upai Mohave Chiricahua Apache Mescale
rapaho Ute Bla Crow Flathead Nez Perce Northern Sh
supai Kaibab Ass a Gros Ventre Piegan Algonkin Bella

The cutting edge of **lan•guage** is a knife.

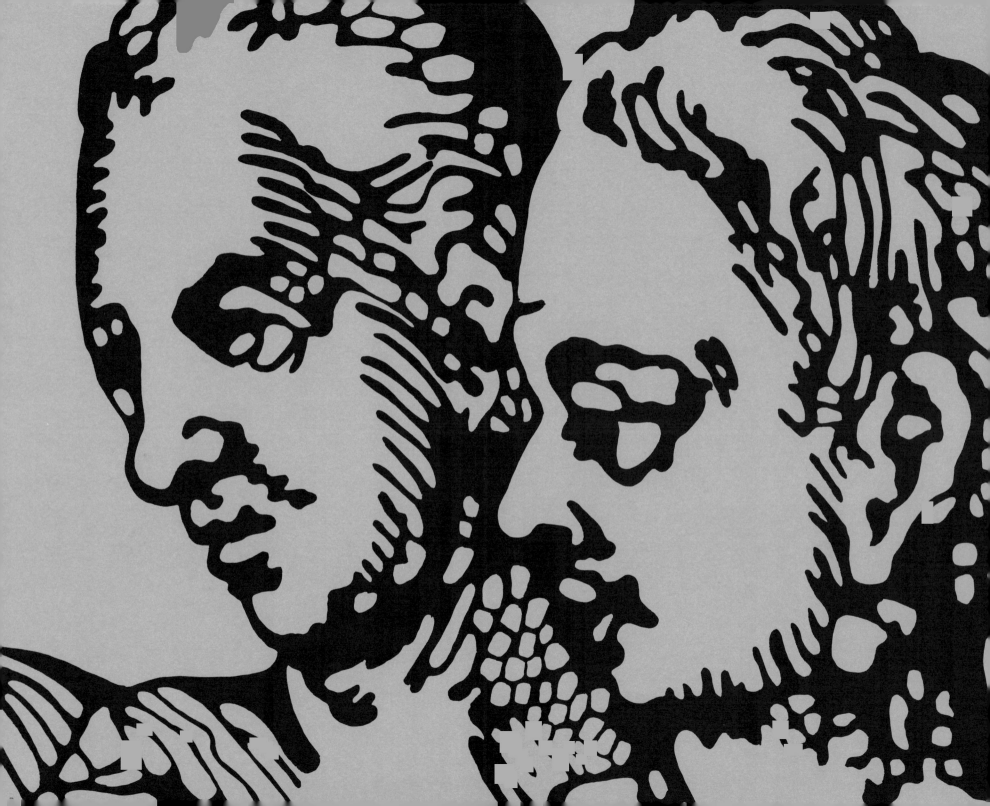

hea•then

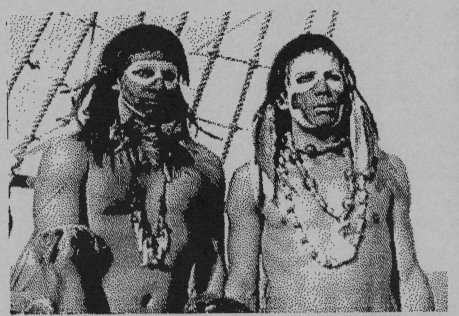

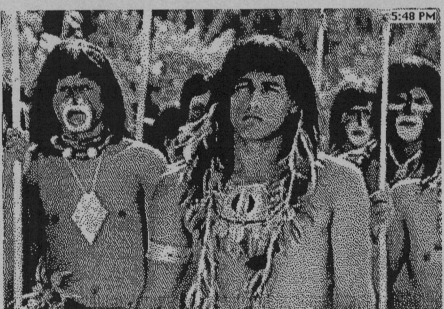

wild • savage • heathen

In *Columbus* by Ingri and Edgar Parin D'Aulaire (recommended by the American Library Association, the Child Study Association, and The California Reading Institute), a child comes across the following passage: **"The Spaniards did not mind being treated like gods by these gentle heathens."**

Ten pages later, the children learn that the "heathens" Columbus meets on his Second Voyage are not gentle but **"wild"** cannibals who eat their enemies and shoot the white men with poisoned darts.

I look up "heathen" in my Thorndike Junior Dictionary. The dictionary uses the word in a sentence so I can better understand the proper usage: "The wild savages of Africa are heathen."

There are **wild • savage • heathens** everywhere.

wild

wild (wild), **1.** living or growing in the forests or fields; not tamed; not cultivated: *The tiger is a wild animal. The daisy is a wild flower.* **2.** with no people living in it. **3.** waste; desert: *Much of northern Canada is wild land.* **The wilds** means wild country. **4.** not civilized; savage. **5.** not checked; not restrained: *a wild rush for the ball.*

Wigwam

6. violent: *a wild storm.* **7.** rash; crazy. **8.** wildly. *adj., n., adv.*

wild cat (wild′kat′), **1.** a wild animal like a common cat, but larger. A lynx is one kind of wildcat. **2.** wild; reckless; not safe. *n., adj.*

wil der ness (wil′dər nis), wild place; region with no people living in it. *n.*

sav age (sav′ij), 1. wild: *He likes savage moun-tain scenery.* 2. not civilized; barbarous: *Gaudy colors please a savage taste.* 3. person living some-what as wild animals do. 4. fierce; cruel; ready to fight: *The savage lion attacked the hunter.* 5. a fierce, brutal, or cruel person. *adj., n.*

sav age ly (sav′ij li), in a savage manner. *adv.*

sav age ness (sav′ij nis), 1. wildness: *the savageness of a jungle scene.* 2. savage or uncivilized condition: *the savageness of some African tribes.* 3. cruelty; fierceness. *n.*

sav age ry (sav′ij ri), wildness; savage state; cruelty. *n., pl.* **sav age ries.**

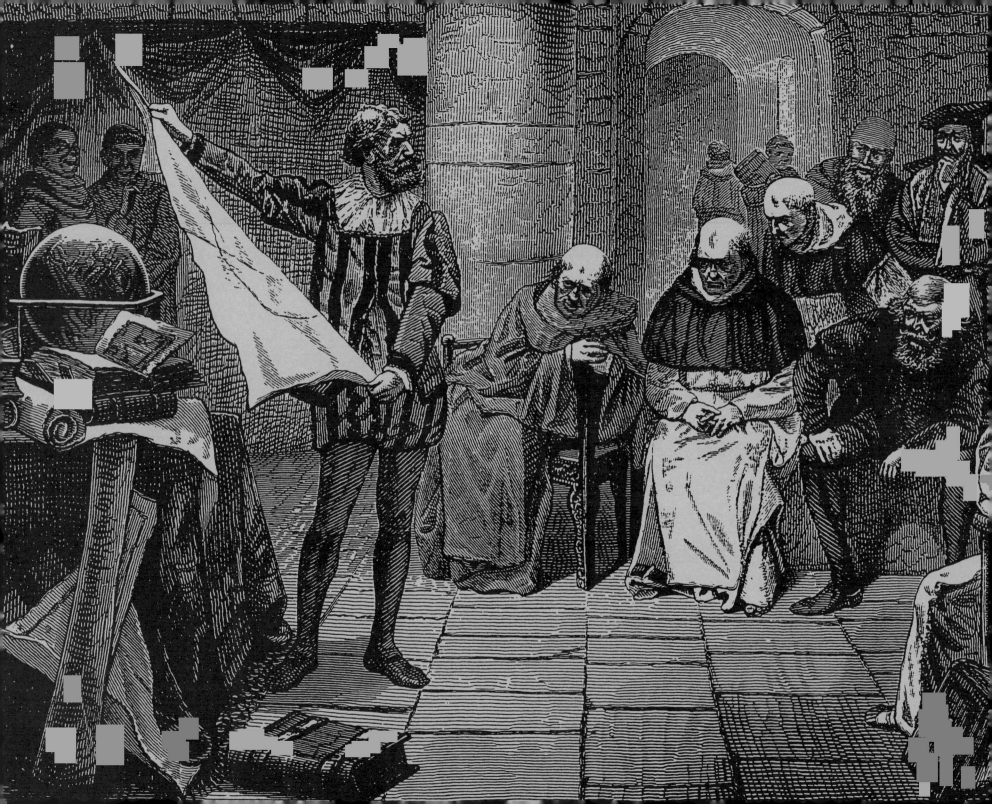

god•gold•glory

October 13, 1492:

I was bent upon finding out if there was gold. . . .

October 15, 1492:

I do not wish to tarry, in order to reach and visit many islands so as to find gold.

November 12, 1492:

. . .they indicated by signs the people collect gold *on the beach at night by candlelight.*

. . .without doubt there are in these lands very great quantities of gold.

December 23, 1492:

They named among other places Cipango, which they call Cibao, and there they affirm there is great quantity of gold, *and its Cacique carries banners of hammered* gold.

January 8, 1493:

A river all full of gold, *to such an extent that it was a marvel. . . .*

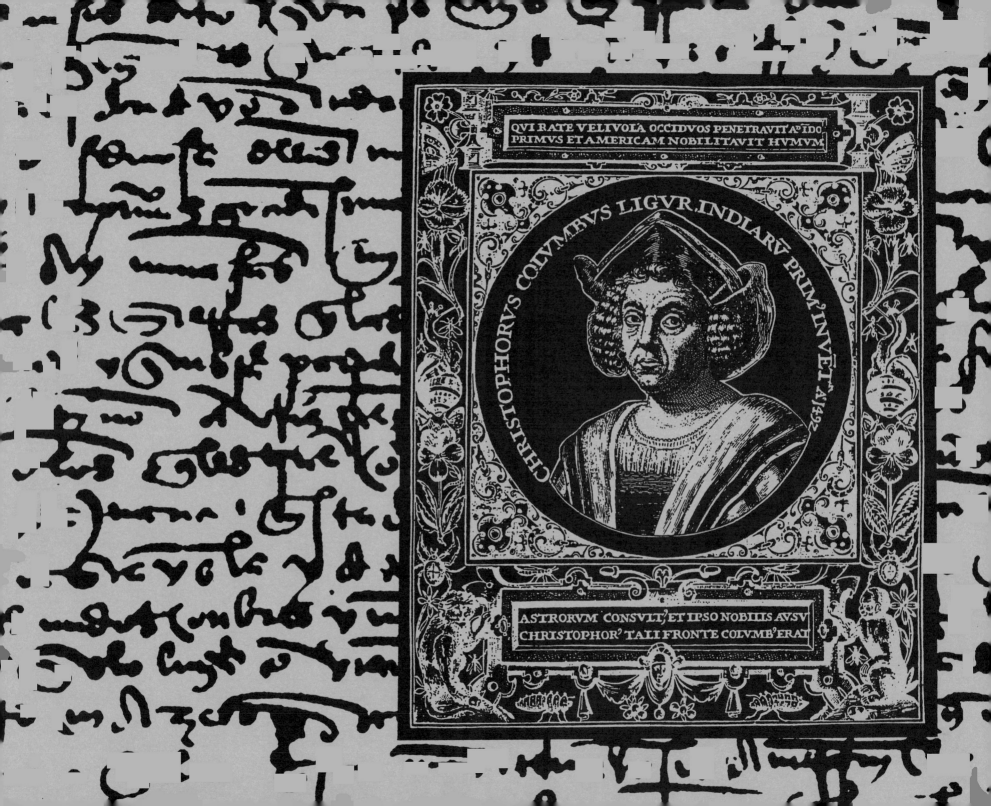

QVI RATE VELIVOLA OCCIDVOS PENETRAVIT AB IDO.
PRIMVS ET AMERICAM NOBILITAVIT HVMVM

CHRISTOPHORVS COLVMBVS LIGVR. INDIARV PRIM INVET AÑ 1492

ASTRORVM CONSVLT ET IPSO NOBILIS AVSV
CHRISTOPHOR TALI FRONTE COLVMB ERAT

Gold: its abundance in the Indies, 14, 56, 88, 236, 367, 369, 375, 383n, 384; and blood, 340, 367; and Columbus, 13, 20, 21, 369; cost of, 367; debased, 379; detrimental effect of, 290n, 375; its effect on scientific research, 375n; and Enciso, 80; fed to Spaniards, 340n; fluidity of, 376–77; God's gift to the Spaniards, 374, 382n, 383, 384; in Hispaniola, 18, 70, 370; historical role of, 374–76; in Jamaica, 21; as lure to the Indies, 55, 56, 319, 366–73; as mainspring of Spanish action, 368–69; mentioned in capitulations, 118; and Michele da Cuneo, 31; origin of, 66; and Peter Martyr, 51, 57, 73, 375–76; as ransom for Holy Sepulcher, 21n, 384; reflected in colonists' faces, 366–67; in rivers, 73, 370; scorned by natives, 55n, 114; as sole appeal of the Indies, 121; and spices, 369–76. *See also* El Dorado

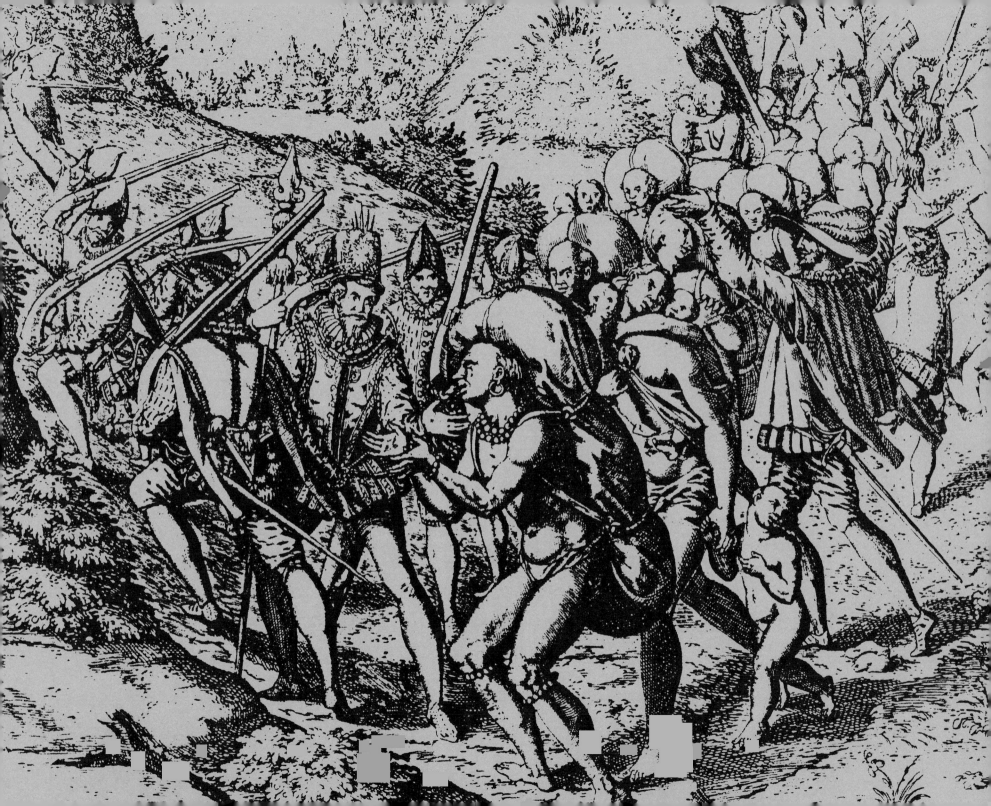

From here one might send, in the name of the HOLY TRINITY, as many slaves as could be sold, as well as a quantity of Brazil [timber]. If the information I have is correct, it appears that we could sell four thousand slaves, who might be worth twenty millions and more.

Christopher Columbus, 1498

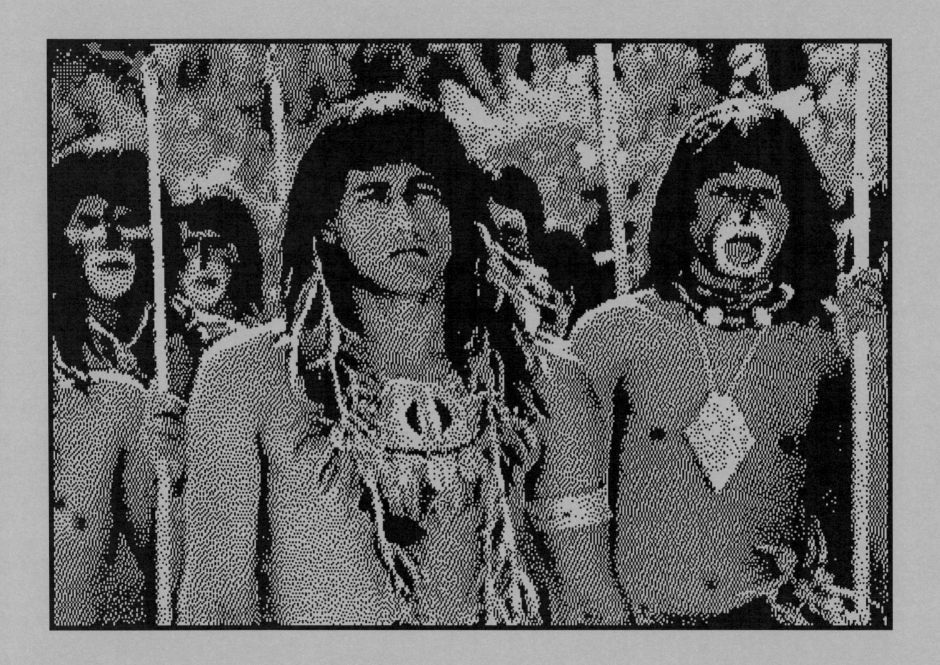

captives • christians • columbus

There's only one solution.

It goes against everything I've ever believed in.

We must make immediate arrangements for the transportation of the **captives** to the slave markets of Seville.

At least there they'll have the opportunity for a decent life and the chance to become **Christians**.

Besides, they will bring gold to those who demand it.

A reluctant Christopher **Columbus**
in a 1986 (CBS) television biography

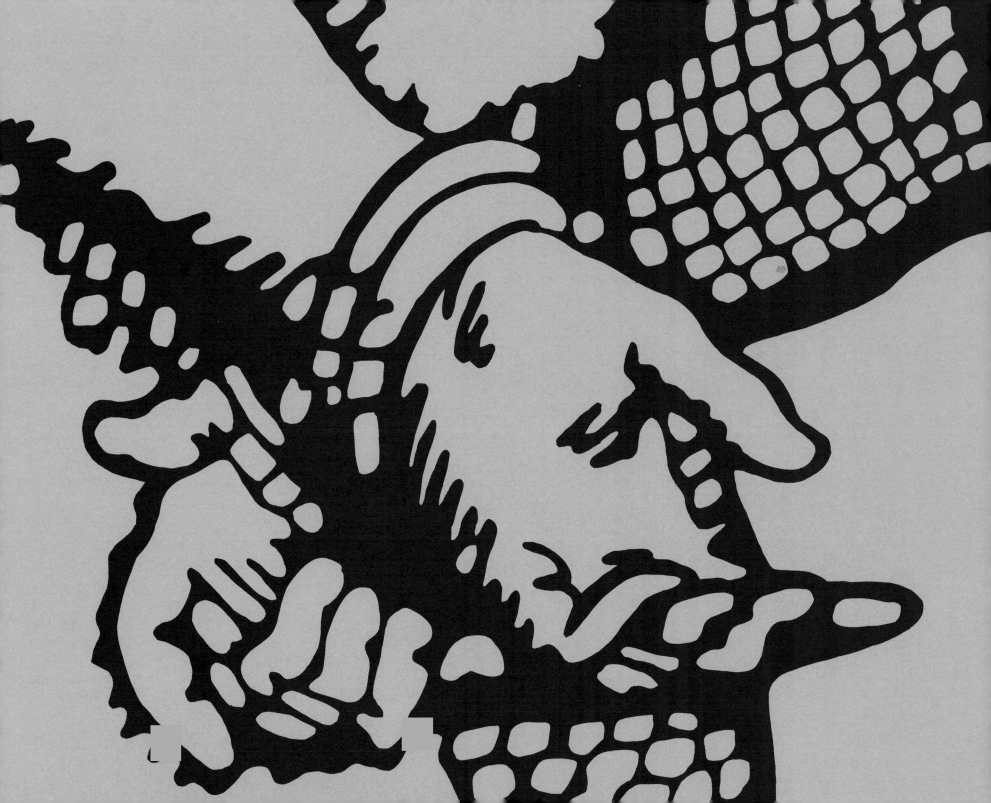

Obliged to depart for Spain, our caravels, on which I wished to go back home, had collected into the town sixteen hundred men and women of the said Indians, of whom, male and female, we loaded the said caravels with five hundred fifty of the best on February 17, 1495. . . . When we got into Spanish waters there died on our hands about two hundred of the said Indians, whom we threw into the sea, the cause I believe to be the unaccustomed cold. . . . We landed all the slaves at Cadiz, half of them sick. They are not people suited to hard work, they suffer from the cold, and they do not have a long life.

Michele de Cuneo describing the shipment of 550 slaves to Castile, 1495

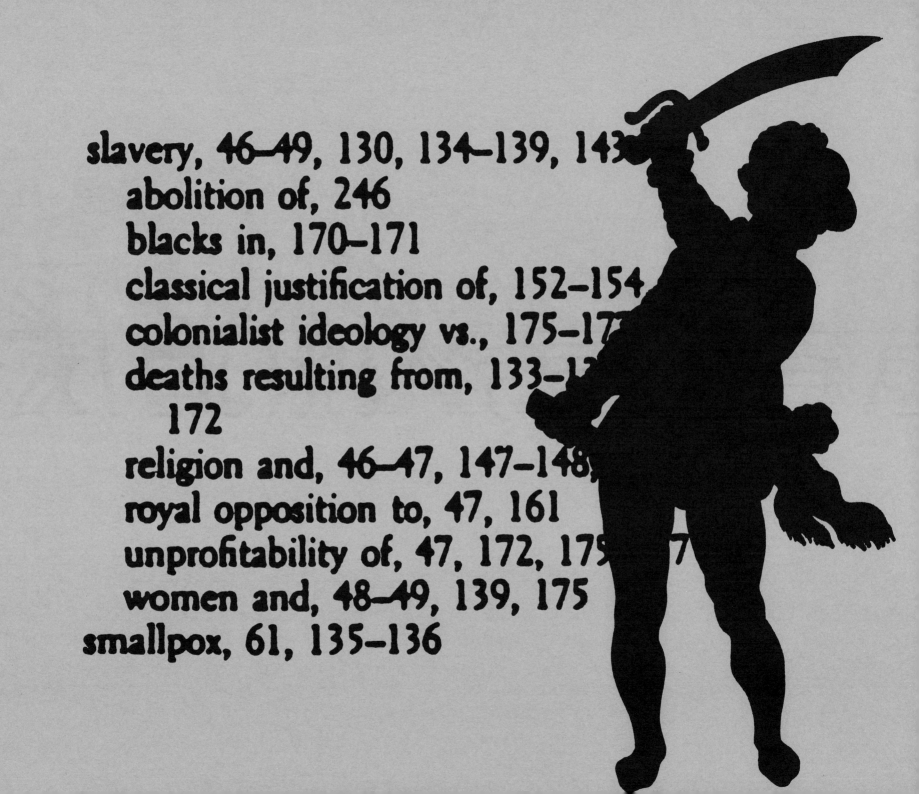

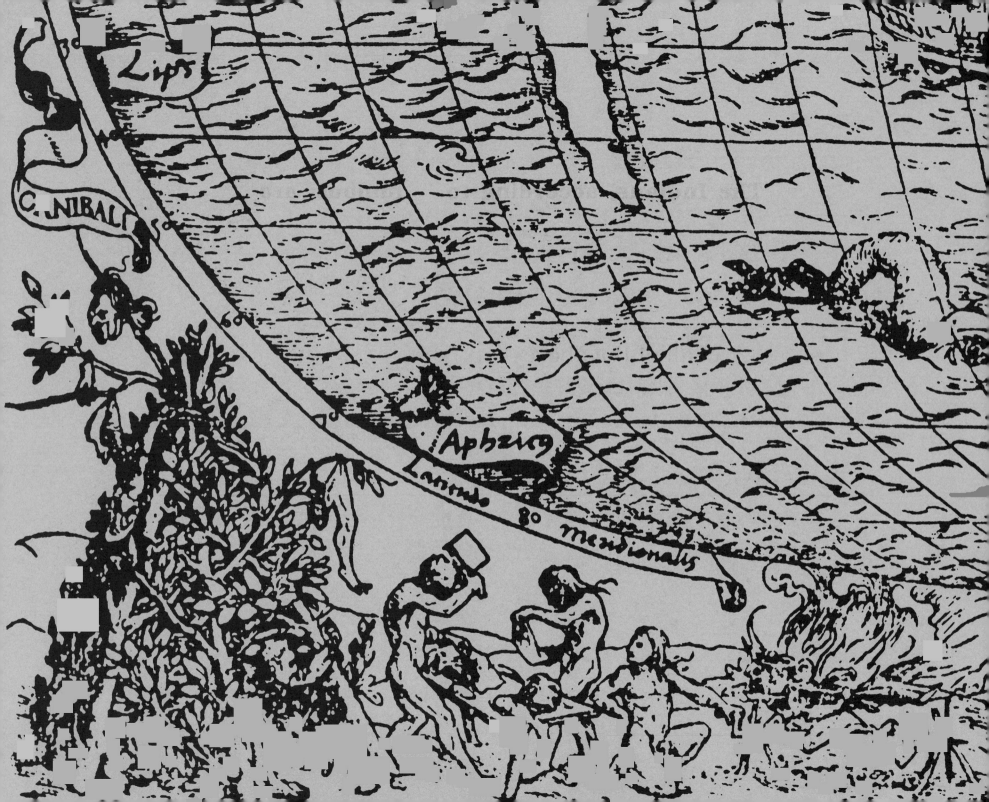

can•ni•bal

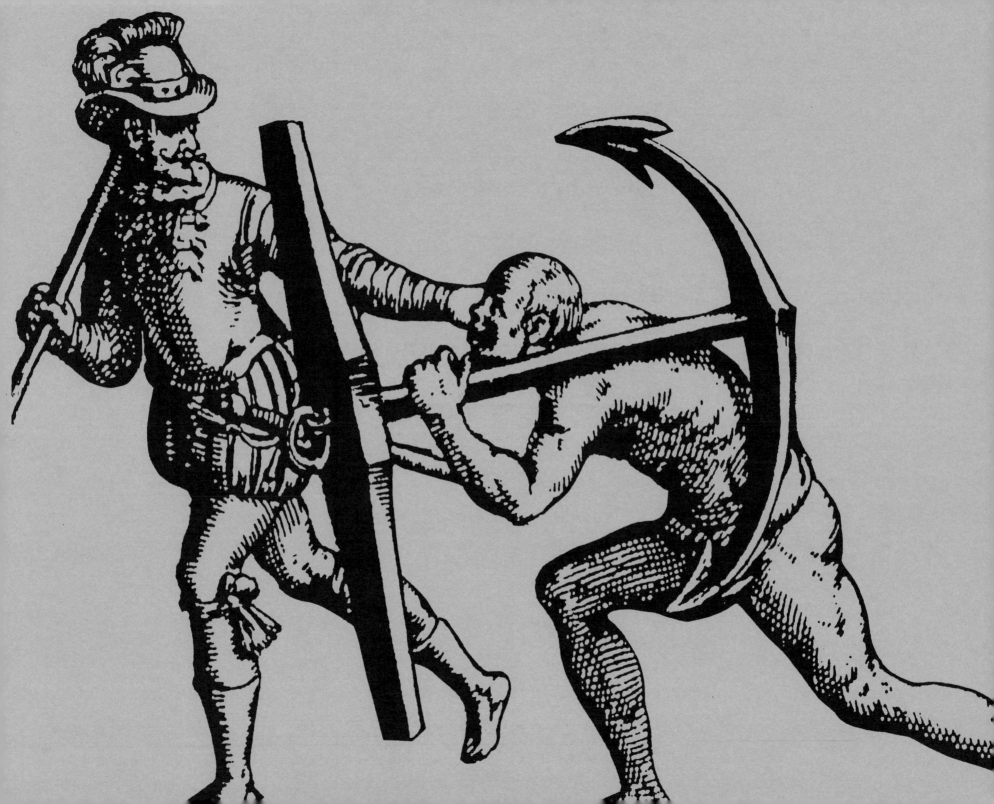

carib = cannibal = slave

. . . if said Cannibals continue to resist and do not wish to admit and receive to their lands the Captains and men who may be on such voyages by my orders nor to hear them in order to be taught our Sacred Catholic Faith and to be in my service and obedience, they may be captured and taken to these my Kingdoms and Domains and to other parts and places and be sold.

Queen Isabella, 1503

The conveyers could be paid in cannibal slaves, fierce but well-made fellows of good understanding, which men, wrested from their inhumanity, will be, we believe, the best slaves that ever were.

Christopher Columbus, 1494

INCOGNITA

winning • whiter • wenches

In the Bahamas, Cuba, and Hispaniola they found young and beautiful women, who everywhere were naked, in most places accessible, and presumably complaisant.

Elsewhere in Cuba there was not much contact with the natives, but friendly relations were established in Hispaniola in December, where the **wenches** were **whiter** and more beautiful than those of Cuba.

Pulitzer Prize-**winning** biography
of Columbus, *Admiral of the Ocean Sea*,
by Samuel Eliot Morison, 1942

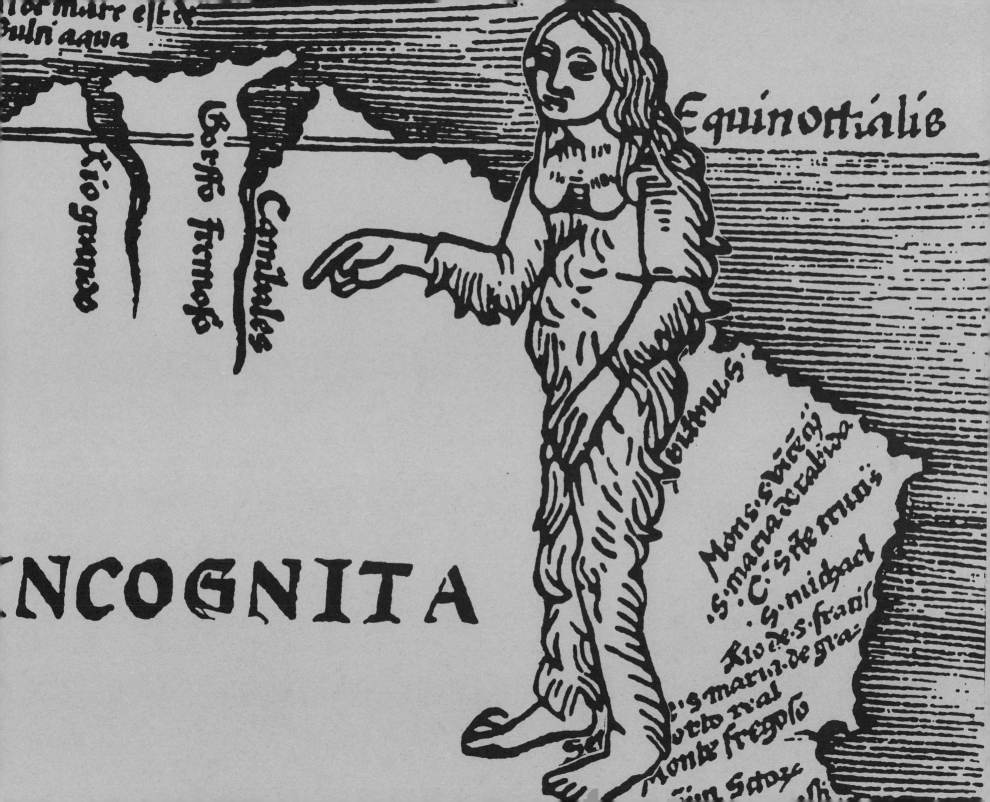

In accordance with the general Nature of women, who prefer the things of others to things of their own, these women love CHRISTIANS most of all.

Peter Martyr, *Decades de Orbe Novo VII*
(Martyr was present at the Spanish court when Columbus returned from his first voyage.)

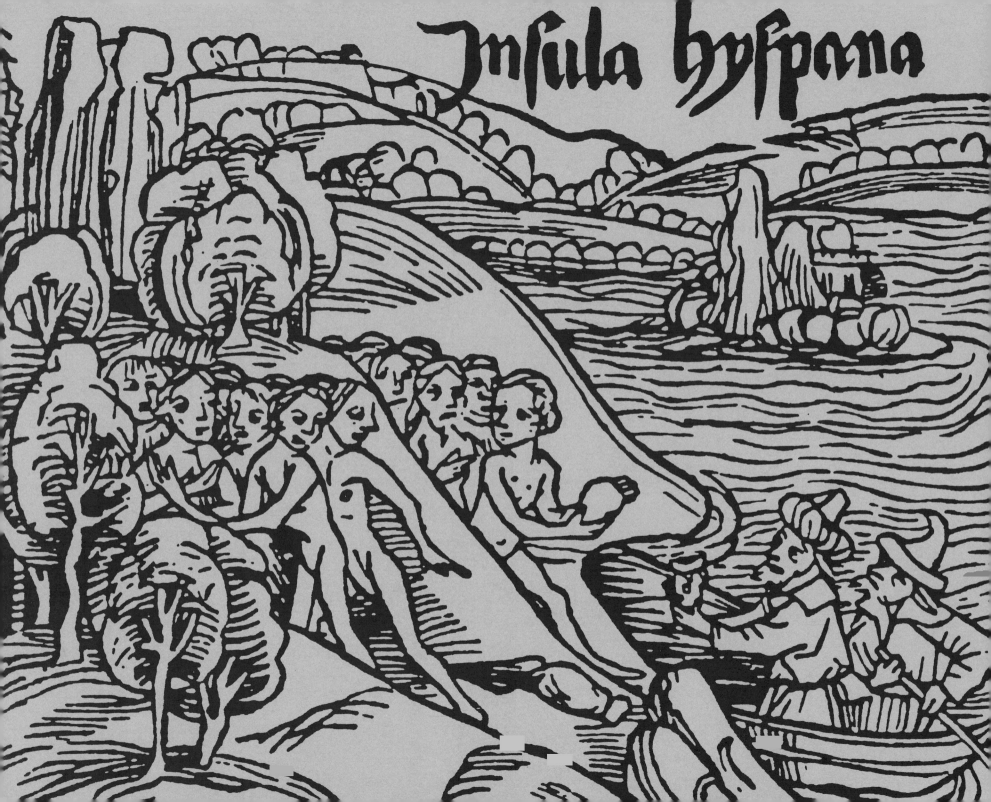

The West is a **vir•gin**.

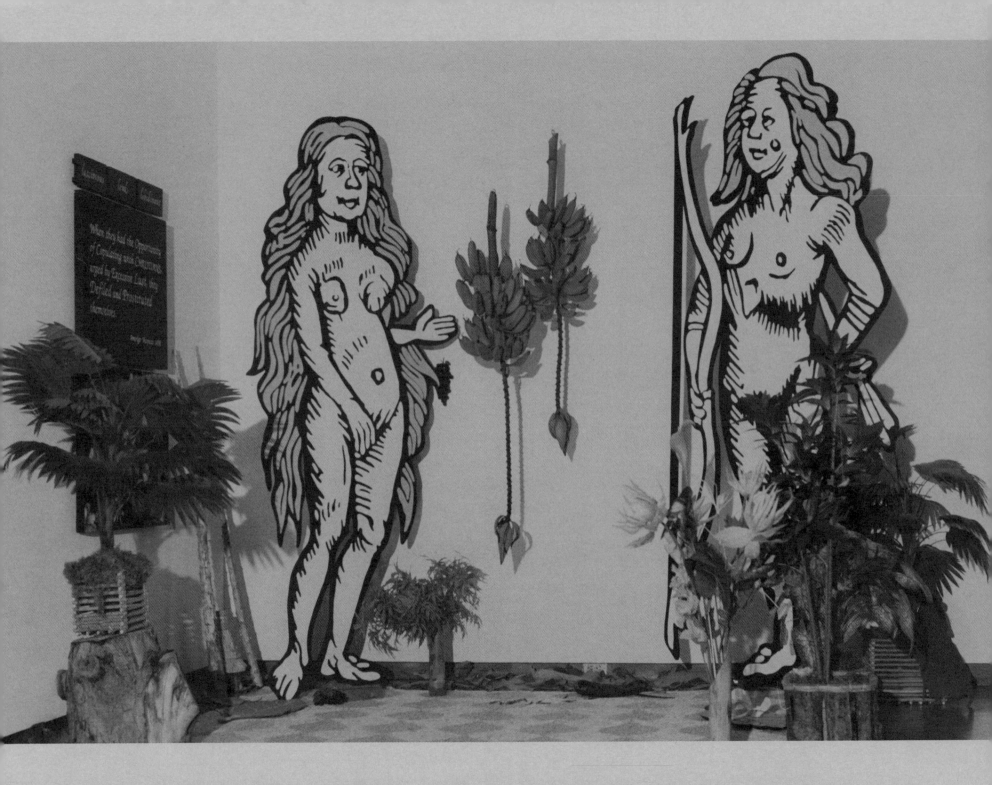

When they had the opportunity of Copulating with CHRISTIANS, urged by excessive Lust, they Defiled and Prostituted themselves.

Amerigo Vespucci, 1498

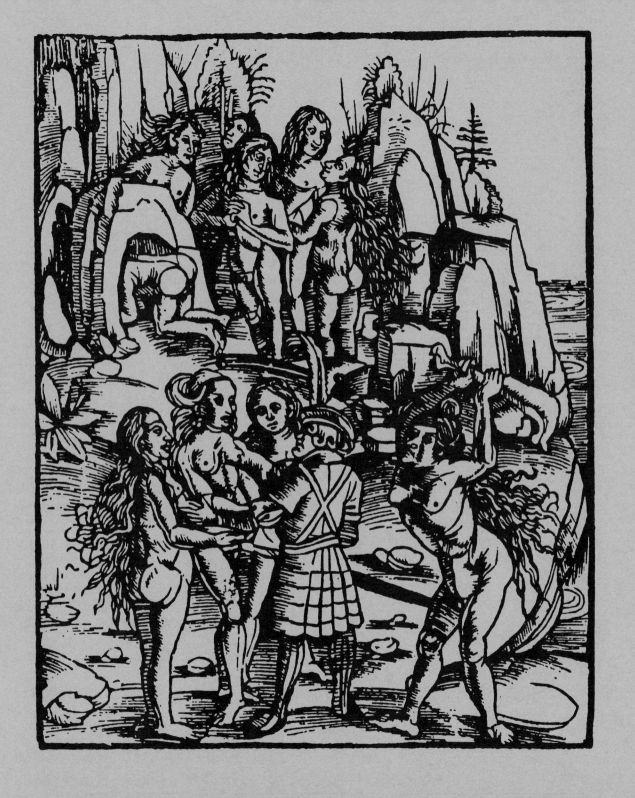

The West is always a **vir•gin**.

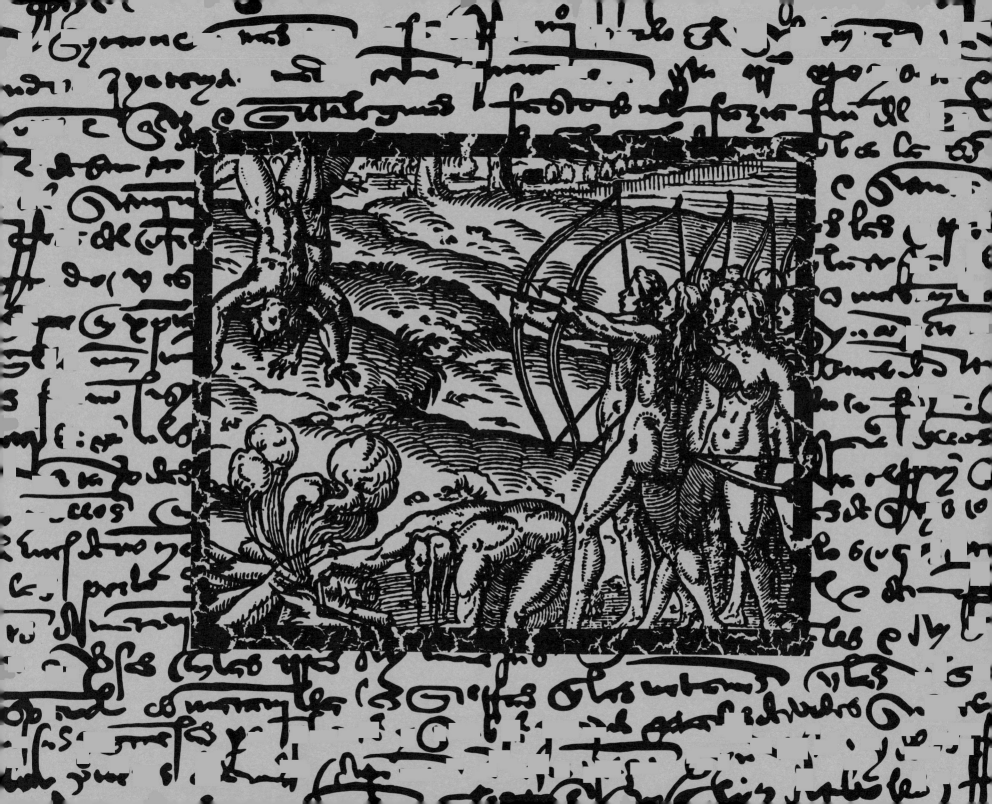

am•a•zon

DANGEROUS • DESIROUS • DEADLY

I am a wild woman,
from the deep, deep mora bush,
from the high mountain top.
I am going to carry someone away.
I wonder who it will be.

<div align="right">

Carib Indian song from Guyana,
quoted in *The Wild Woman*

</div>

It is 1493. In his letter to Isabella and Ferdinand, Columbus reports finding parrots, gold, and warrior women. His warrior women are the legendary Amazons who live without men and use bows and arrows to defend their gilded island from invasion. Once a year they procreate with ferocious cannibals from a nearby island.

It is 1510. Columbus's description of exotic Carib Amazons inspires Garci-Rodríguez de Montalvo's romance of the chivalric hero, Amadis, who fights and subdues Queen Calafia and her Amazons. Queen Calafia's island paradise is called "California."

"Know then, that on the right hand of the Indies, there is an island called California, very near the Terrestrial Paradise," Montalvo writes.

It is 1989. Paradisiacal California and Amazon women both make an appearance in the movie, *Cannibal Women in the Avocado Jungle of Death.* Released by Guacamole Productions, *Cannibal Women* not only parodies the deadly Amazon legend so dear to Columbus's heart, but also takes on Joseph Conrad's *Heart of Darkness*, Francis Ford Coppola's *Apocalypse Now*, as well as contemporary feminist theory.

In *Cannibal Women*, ethno-herstorian Margo (Marlow) Hunt and sidekick (playboy) Bunny enter the treacherous, uncharted avocado jungle to find the missing Dr. Francine Kurtz, feminist author of *Smart Women, Stupid, Insensitive Men.* Two years earlier, Kurtz had ventured into the jungle and, like Conrad's Kurtz in *Heart of Darkness*, never returned to "civilization."

The Avocado Jungle, deep in California's heart of darkness, is populated by the beautiful, voluptuous, and deadly Piranha women, who after having sexual intercourse with their captive males, sacrifice and eat them. The Piranha women are cannibals—not merely ballbusters but ball-crushers, ball-consumers, ballconnoisseurs.

Imagine a cannibal . . .

The Cannibal women throw the leftover scraps and bones of any hapless male into the deadly piranha pool. The piranhas merely finish off what the women began.

Feminists, it turns out, deeply and connivingly want what all women want: to dominate men. Their public denial of this fact only signals the

perverse ritual that inevitably follows—sex of the most sordid kind followed by the erasure of any trace. Feminists such as Dr. Kurtz are women who devour like the piranha, the barracuda, the praying mantis.

The *vagina dentata* . . .

It is 1502. Explorer Amerigo Vespucci ups the ante on Columbus. In his description of "New World" women, his female archers don't merely consort with cannibals; Vespucci's warrior women *are* cannibals. Like the California Cannibal Women living in the Avocado Jungle of Death, Vespucci's women are man killers as well as man consumers.

"All women are **WILD**, but some are **WILDER** than others," according to the male fantasies anthropologists Sharon Tiffany and Kathleen Adams examine. The **WILDEST** women, of course, are the most dangerous, the most desirous, the most deadly.

It is 1989. Dr. Francine Kurtz, it turns out, unlike Kurtz in *Heart of Darkness*, has no intention of going native. Intrepid trackers Bunny and Margo discover that the voracious female Kurtz is merely gathering material for her next textual foray, *My Life as a Piranha Woman.* When Margo confronts Kurtz with her deception (the native women think she is now one of them), Kurtz desperately confesses that invitations on the talk-show circuit had waned and sales of *Smart Women* had plummeted.

Without another best-selling book, Kurtz can no longer claim her role as leading feminist spokesperson for smart women or as leading feminist castigator of stupid, insensitive men.

Like her male counterparts, she knows that you're only as good as your next book, your next performance, your next deal, your next hard-on. . . .

Unable to face another appearance on the David Letterman show, *de rigueur* on the talk-show circuit for best-selling authors, Francine Kurtz casts herself into the deadly piranha pool. "The horror! The horror!" she cries before plunging to her death.

The ending of *Cannibal Women*, except for Dr. Kurtz (*she's dead*), is a happy one. Margo returns to the civilized terrain of the university, but first unites the Barracuda and Piranha women who have been fighting for years over whether to eat clam or avocado dip. Jean-Pierre, a handsome and virile male due to have been sacrificed in the piranha pool, follows her to the university and enrolls in a Feminist Studies class. (Playboy) Bunny gets married.

In a probable sequel, scantily clad Margo will appear on the David Letterman show to talk about her adventures with the exotic and scantily clad Cannibal women in the Avocado Jungle. Jean-Pierre, of course, will be waiting for her at home with a drink, an erection, the VCR in reverse. . . .

It is 1510. In Montalvo's tale, Calafia lies awake at night, wondering whether to wear battle armor or more feminine attire to meet her handsome and virile enemy, Esplandian. In the morning, Calafia slips on a gold dress.

"A **dangerous woman** makes a **brave man**," anthropologist Elsie Clews Parsons reminds us.

It is 1510. Domesticated and defanged after battle with the superior, chivalric, and very male Amadis, Queen Calafia forfeits her independence, embraces Christianity, and succumbs to the temptations of love and marriage.

Another triumph of light over darkness.
Another triumph of civilization over savagery.
Another triumph of patriarchy over matriarchy.

It is 1542. Fifty years after Columbus's "discovery," the Brazilian river is named the "Amazon" by Francisco de Orellana, who is sure he has sighted the legendary warrior women. The same year "California," named after kneeling Queen Calafia, is noted in the log book of Juan Cabrillo as he sails north from New Spain. Conquistadors in both the "Old" and "New" worlds read Montalvo's chivalric romances, which give meaning and nobility to their search for these dangerous, desirous, and deadly women.

As for the gold, it is always said to be close at hand.

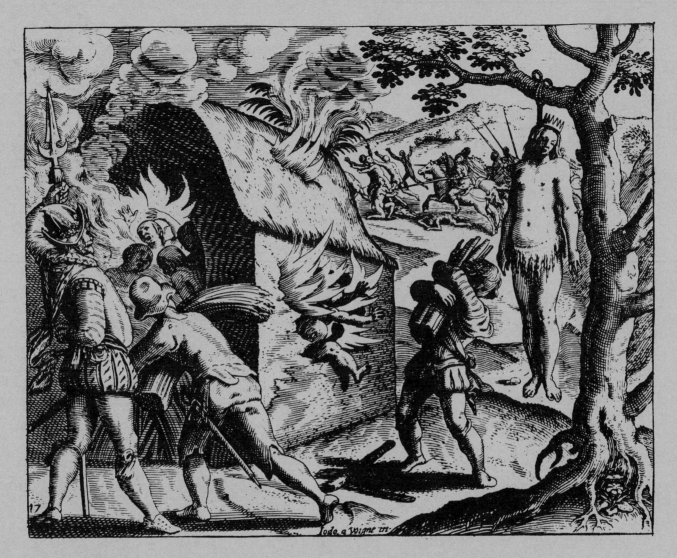

Xaraqua quartum Regnum est, quasi centrum, & medium
totius Insulæ; in diserto sermone, & eloquenti idiomate par ex
cæteris Regnis non habet; in politia verò, & bonis moribus, re-
liquis excellit. In eo maxima erat Dominorum, & nobilium co-
pia, & ipsa plebs statu, habituq; corporis præstabat. His Behe-
chio Rex erat, qui sororem Anacaona nomine; habebat. Vter-
que & frater & soror, Hispanos insignibus beneficiis afficiens,

ANACAONA

QUEEN ANACAONA
Maggie Jaffe

GOLD

Anacaona
wife of Caonabo
(executed for sedition),
sister of Behechio
(executed for sedition),
named *Woman Is Pure Gold.*
What does she feel?
Fear, yes, fear
the snake pressed
against her heart.
Alternately she feels
rage and, oddly, bored.
With them. Their gold-lust,
insatiable appetites.
Barbarians! witness the tiny
man nailed to a tree
worn round their necks:
her eyes drawn
to this bright point of death.

She placates them
with gold, no more valued
than the white sea
shells used for trade.
And with food: coconut fronds
loaded with cassava bread,
shellfish with maize,
sweet potatoes, succulent dog.
Afterward, Chief Speaker lights
up his most potent *cohoba.*
When sated the signal is given:

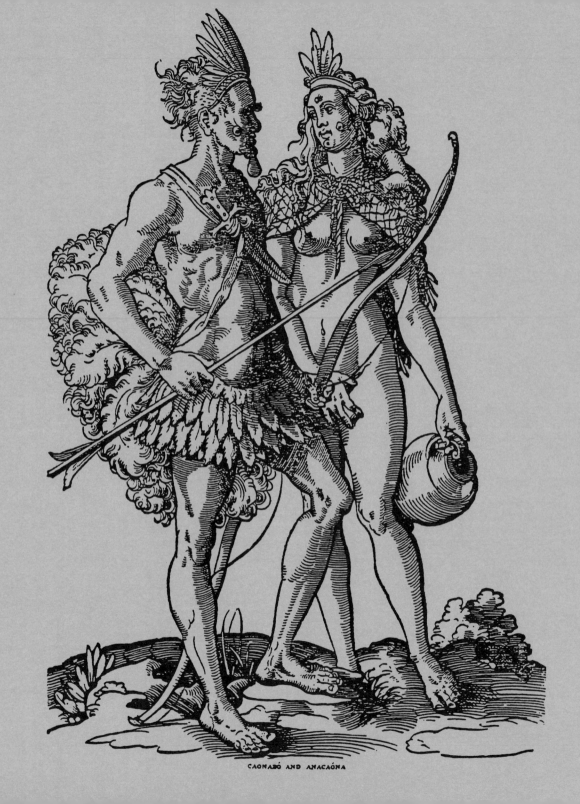

CAONABO AND ANACAONA

GOD

Your worship:
It is imperative that I,
Nicolas de Ovando,
explorer for God and Empire,
relate a most unfortunate altercation
that occurred on Hispaniola, 1503,
autumn, mid-day.

Seventy of us,
hidalgos on horseback,
as well as three hundred foot
soldiers, marched into
their heathen village.
You know our men:
restless, hungry
for women, for pearls, for gold.
To come to the point,
we massacred the savages.
Those we didn't burn
we ran through with our swords.
We decently hanged Queen Anacaona,
although she is, by all accounts,
"queen" of the perfidious whores.
These barbarians are little
more than two-legged dogs.

[Hail Mary, Full of Grace]

GORE

De Bry's illustration for
The Devastation of the Indies
shows a child, no more than twelve,
carrying wood for the *auto-de-fé*.
In the foreground a conquistador
struts in front of burning
bohíos: the screams come
from another country.
In the background
horsebacked conquistadors
test their swords.
Indians run or kneel
imitating a Christian's posture
of mercy.

Anacaona,
first woman named
first woman hanged
wears the crown as
the lamb's simulacrum.
Her face, half darkness,
half light, is according
to Las Casas, "gracious,
dignified, benevolent."
The flames, her crown
the tree's gnarled roots.

Iconography of genocide . . .

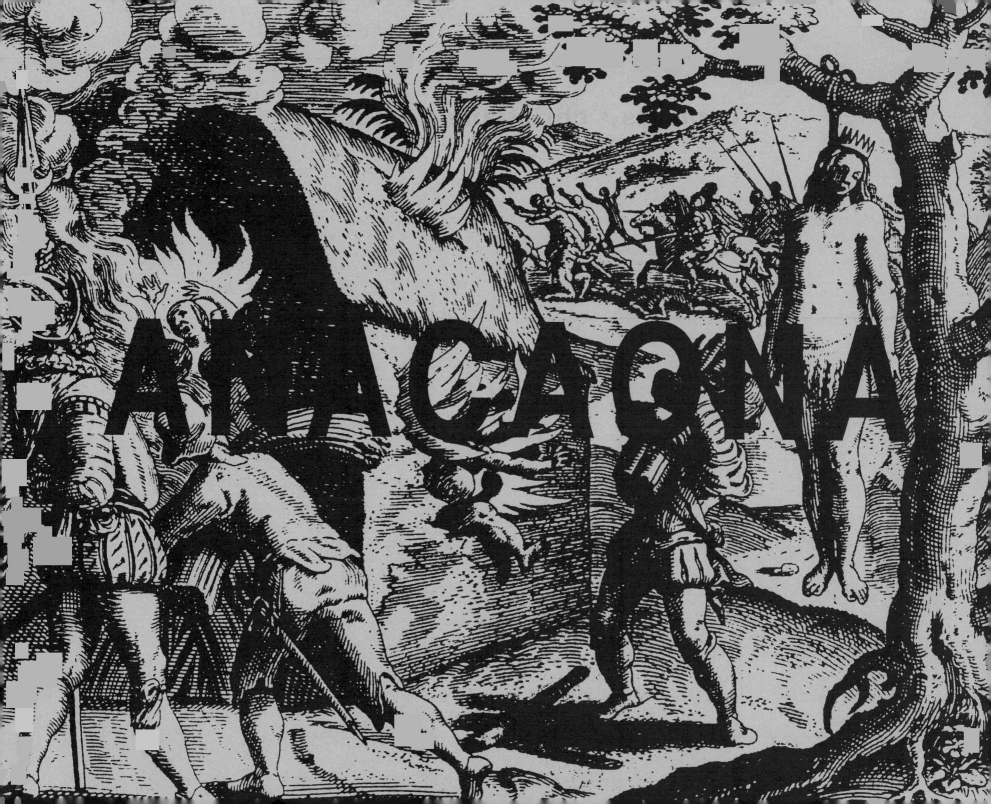

GUACANAGARI • CAONABO • ANACAONA

I

It is 1493. In January, thirty-nine men are left behind to guard the fort at La Navidad in the "New World" while a triumphant Columbus sails back to Spain with parrots, gold, Indians.

It is 1493. In November, Columbus returns to the "New World," this time with a fleet of 17 ships, 1500 men, as well as horses, dogs, armor, and cannons. The thirty-nine men who had been left on Hispaniola to guard the fort at La Navidad are found dead. Guacanagari, who had helped Columbus construct the fort from the timbers of the *Santa María*, blames the deaths on Caonabo, a cacique from the interior.

Later, Gonzalo Fernández de Oviedo (official Chronicler of the Indies), writes that the "natives could not endure the excesses, for they [the Spaniards] took their women and used them as they wished and committed other violences and offenses. . . ."

It is 1493. The honeymoon period of the "discovery" is already over.

It is 1494. Caonabo eludes the grasp of the conquistadors. "Treat him thus with words until you have his friendship, in order the better to seize him," Columbus tells his soldiers. Columbus's lieutenant Hojedo invites Caonabo to visit the "great white chief." He gives the cacique European gifts—brass handcuffs and foot shackles. Unaware of their purpose, Caonabo allows them to be placed upon him. The Spaniards seize Caonabo and deliver him to Columbus. In irons and chains, he is displayed as a warning to other "rebellious" Indians.

It is 1496. Caonabo, leader of the first indigenous resistance to the European invasion, is loaded for shipment to Spain with twenty-nine other prisoners. Caonabo will die at sea.

II

It is 1503. Nicolás de Ovando, governor of Hispaniola, marches into Xaragua with his men to pay a visit to Anacaona. Widow of Caonabo, she now governs the western half of the island.

"Lady Anacaona and the many noble chieftains of the province, all very dignified, generous, and far more polite, virtuous people than the [Christian] people of this island," according to Bartolomé de Las Casas, "felt the presence of the Spaniards to be excessively onerous, pernicious, and altogether intolerable. . . ."

In the middle of a banquet prepared for the colonizers, Ovando gives the signal for the massacre to begin. The surprised and overwhelmed caciques are burned to death or hacked into pieces. "As for the Queen, they hanged her as a mark of honor," Las Casas writes.

III

Oviedo, official historian, tells us why this massacre, like countless massacres that will follow, is necessary. It is the *threat* of insurrection, he explains, that precipitates slaughter.

Insurrections, **uprisings**, **rebellions**, **revolts**...

Las Casas interprets the massacre differently: "[Ovando] decided to perform what Spaniards always perform on arrival in the Indies, that is to say, when they come to a heavily settled area, being so outnumbered that they make sure all hearts tremble at the mere mention of the name Christians; therefore, they terrorize the natives by performing a large-scale and cruel massacre."

IV

It is 1598. In one of Theodore de Bry's illustrations of Las Casas's *Brief Account of the Devastation of the Indies*, a woman hangs from a tree. On her head is a crown. Conquistadors heap wood on the fire to fan the flames engulfing the nearby *bohío* and its inhabitants. The woman is Anacaona.

"Satan has now been expelled from the island [Hispaniola]," Oviedo writes. "Who can deny that the use of gunpowder against pagans is the burning of incense to Our Lord."

V

In his official history, Oviedo tells us about the sexual predilections of the native women of Hispaniola: "[They] were restrained with the native men, but they gladly gave themselves to the Christians." Anacaona, in particular, was "very indecent in the venereal act with the Christians" and "the most dissolute woman of her rank or any other to be found in the island."

According to Oviedo, Anacaona, like (all) other (native) women, is a willing participant in her own degradation.

In his *Brief Account of the Devastation of the Indies*, Las Casas contradicts Oviedo's account of the massacre, as well as his depiction of Anacaona: "So noble and fine a lady, so gracious to the Christians and long suffering of their insults."

VI

It is 1975. Anacaona not only must suffer the insults of the conquistadors and Oviedo but of contemporary **HIS**torians as well. In *Nature in the New World,* Antonello Gerbi describes Anacaona as a "New World" *femme fatale*—"crafty and lascivious." Gerbi discovers his insight in Oviedo rather than Las Casas.

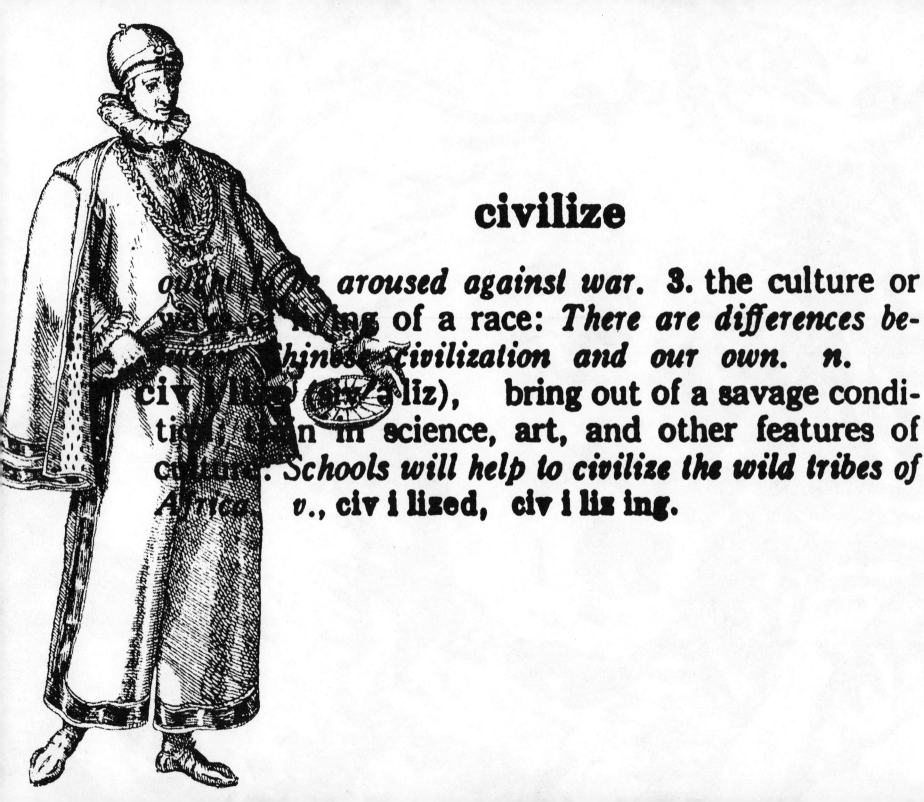

civilize

... aroused against war. **3.** the culture or ... of a race: *There are differences be- tween Chinese civilization and our own.* **n.**

civilize (siv'ə līz), bring out of a savage condi- tion ... in science, art, and other features of culture. *Schools will help to civilize the wild tribes of Africa.* **v.,** **civ i lized, civ i liz ing.**

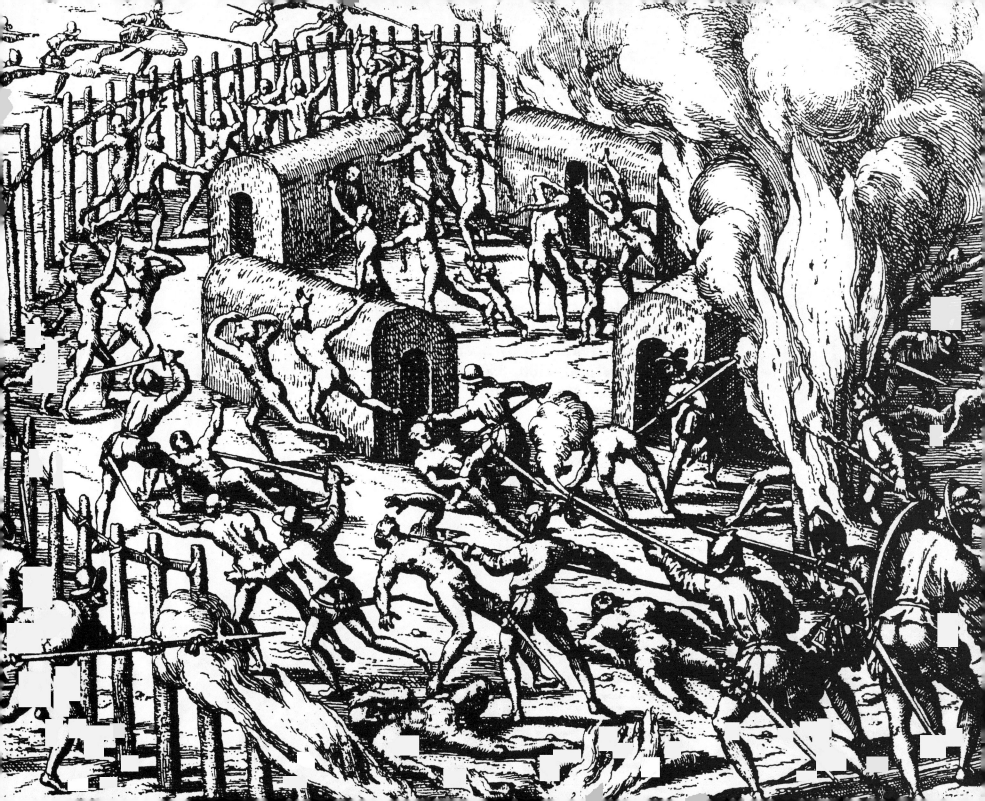

I

It is 1492. "We will convert them by Love rather than by Force," Columbus writes.

As point man for colonization and agent of Imperial Spain, Columbus sets out to conquer the hearts and minds of the "New World's" inhabitants. Soon Columbus finds that **love** is insufficient. His men have confused love with rape and plunder, and the Indians fight back. Love may be Columbus's first choice for his colonizing mission, but **force** is the reality of his enterprise.

II

It is 1493. "While I was in the boat, I captured a very beautiful Carib woman, whom the aforesaid Lord Admiral [Columbus] gave to me, and with whom, having brought her into my cabin, and she being naked as is their custom, I conceived the desire to take my pleasure," Michele de Cuneo writes.

His paradise . . .
His pleasure . . .
His prerogative . . .

Columbus "gives" a captured Carib woman to Michele de Cuneo, a friend who accompanies him on his Second Voyage to the "New World."

She is captured near the island now called St. Croix in the Caribbean.

"I wanted to put my desire to execution, but she was unwilling for me to do so, and treated me with her nails in such wise that I would have preferred never to have begun."

All women are **wild** but some are **wilder** than others, myth and folklore tell us, according to the authors of *The Wild Woman*.

"But seeing this (in order to tell you the whole even to the end), I took a rope-end and thrashed her well, following which she produced such screaming and wailing as would cause you not to believe your ears."

She screams, but then **succumbs** . . .
She wails, but then **submits** . . .
She resists, but then **surrenders** . . .

"Finally we reached an agreement such that, I can tell you, she seemed to have been raised in a veritable school of harlots."

Writer, swashbuckler, perpetrator, Michele de Cuneo vividly describes the Carib woman's transition from an intractable and naked woman to a tractable and insatiable harlot in the space of only four sentences. His "natural" desire has become her unnatural lust, degraded and dissolute. A "harlot's" lust.

De Cuneo's narrative, the first documented rape in the "New World" written by the protagonist himself, is the stereotypical rape scenario where a woman at first resists, but then succumbs voluptuously to what she desired all along. The tenacious power of this scenario—women "ask for it" because of the way they are dressed, "no" really means yes, and women enjoy being raped—means that rape is an intricate display of deception on the part of women who are not victims but the perpetrators of their own desire to surrender to self-evidently superior male Europeans.

III

It is 1493. Rape precipitates the first indigenous resistance against the European invaders on the island named Hispaniola. The rapes of indigenous women presage and are simultaneous with the "rape" of "virgin" land, the taking possession, naming, and subjugating of the "New World."

IV

It is 1498. "When they had the opportunity of copulating with Christians, urged by excessive lust, they defiled and prostituted themselves," Amerigo Vespucci writes.

It is 1589. The artist, Jan van der Straet, (Stradanus) depicts that first glorious moment when Amerigo Vespucci debarks on the shores of the "New World." A naked woman sits in a hammock surrounded by exotic flora and fauna. Vespucci has just discovered and awakened her from a deep and dark slumber, and therefore she (the hemisphere) is named after him. *America* is *Amerigo*, feminized.

The **WEST** is a **VIRGIN**.
I am her White Knight.

The feminized "New World" is a pliant body to be penetrated, then domesticated and defanged.

VI

It is 1991. "New World" women bear little relation to their contradictory representations in "Old World" chronicles, diaries, journals, letters, and images. Columbus and Vespucci, as well as the explorers who accompanied them, depicted the women as innocent and submissive, or alternately as lascivious and insatiable. The conquistadors were drawing on an already established pantheon of images of women as Amazons, mermaids, nymphs, wild women, hags, and harlots. Wedged between the **prisonhouse • of • language** and the **slaughterhouse • of • history,** the women are projections of the explorers' fears and fantasies.

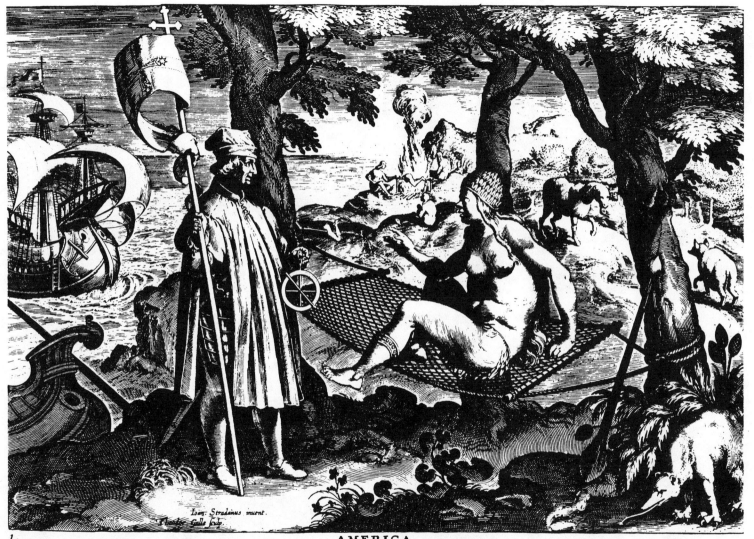

Ioan. Stradanus inuent.
Theodor. Galle Sculp.

1. AMERICA.

Americen Americus retexit, & *Semel vocauit inde semper excitam*

What is it like to be **discovered?**

his **colonizing** gaze
his **colonizing** desire
his **colonizing** pleasure
his **colonizing** imagination
his **colonizing** inscription
his **colonizing** penetration
his **colonizing** terror
his **colonizing** obsession
his **colonizing** description
his **colonizing** perspective
his **colonizing** scrutiny
his **colonizing** discovery
his **colonizing** discourse
his **colonizing** enterprise
his **colonizing** quest
his **colonizing** exploration
his **colonizing** intervention
his **colonizing** domination
his **colonizing** domestication
his **colonizing** exploitation
his **colonizing** articulation
his **colonizing** force
his **colonizing** history

I

It is 1942. "If I were to select a shipmate from all the companions of Columbus, he would be no haughty if heroic Castilian, but merry Michael of Savona [Michele de Cuneo]," Samuel Eliot Morison writes in his Pulitzer Prize-winning biography of Columbus.

According to Morison, Michele de Cuneo's account of the Second Voyage written in 1495 was the "most sprightly narrative" written:

"That genial gentleman adventurer never complained, but extracted interest or amusement from everything that happened," Morison tells us.

Exploitation can be adventurous and rape can have a charm all its own.

II

It is 1405. "I am therefore troubled and grieved when men argue that many women want to be raped and that it does not bother them at all to be raped by men even when they verbally protest," Italian historian Christine de Pizan writes in *The Book of the City of Ladies.* "It would be hard to believe such great villainy is actually pleasant for them."

It is 1405. Ninety years before Michele de Cuneo writes that **no no no** really means **yes yes yes**, Christine de Pizan refutes the proposition that women want to be raped.

III

It is 1982. Four hundred eighty-seven years after de Cuneo tells us that **no no no** really means **yes yes yes**, literary critic Tzvetan Todorov refutes the proposition that refusal is hypocritical. For Todorov, the Carib woman is not a "harlot" but the "object of a double rape," as an Indian and as a woman. Todorov refuses to continue the travesty that de Cuneo's narrative is just another account of a jolly adventure by a good old boy.

IV

It is 1493. After the fight on St. Croix, Columbus and his fleet sail off and sight island after island. Columbus names them the Virgin Islands after Ursula and her 10,999 seagoing Virgins, who were brutally slaughtered by Atilla and his Huns.

Hail Mary, Full of Grace.

These islands, unlike the Virgin Mary, are ripe for possession, penetration, and plunder.

V

It is 1989. "We all feel she asked for it for the way she was dressed." A jury in Florida acquits a man accused of kidnapping and raping a woman at knifepoint. "With that skirt you could see everything she had. She was advertising for sex," the jury foreman adds.

It is 1989. Twentieth-century jurors confirm what our conquistadors knew when they first set foot in the "New World." Dress, according to the jurors, is the outward sign of a woman's inner desire to be raped.

It is 1493. The Carib woman Michele de Cuneo captures is not dressed but naked, the outward sign of her inner desire to be taken by brute force, beaten, and then raped.

VI

It is 1494. Columbus "gives" an island to de Cuneo. "[I] cut down trees and planted the cross and the gallows too and in God's name I baptized it La Bella Saonese," de Cuneo writes.

According to de Cuneo, there are "37 villages with at least 30,000 souls" on **his** island.

Carib islands
Carib women
Carib souls

European gallows . . .

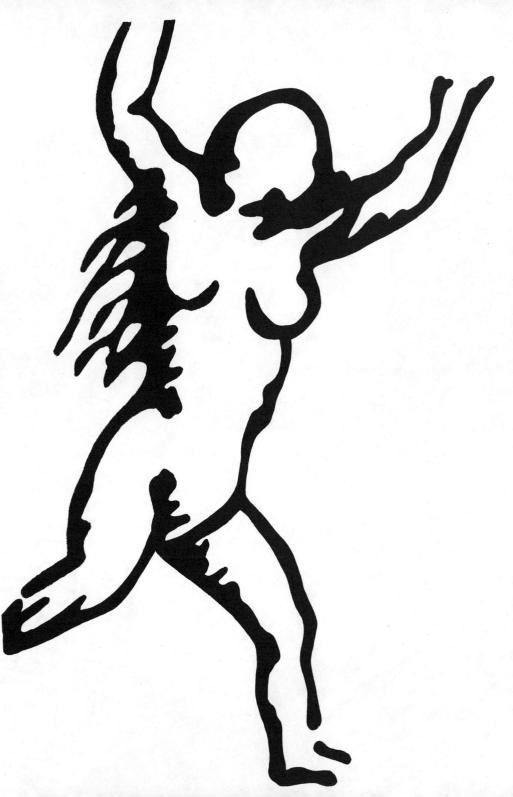

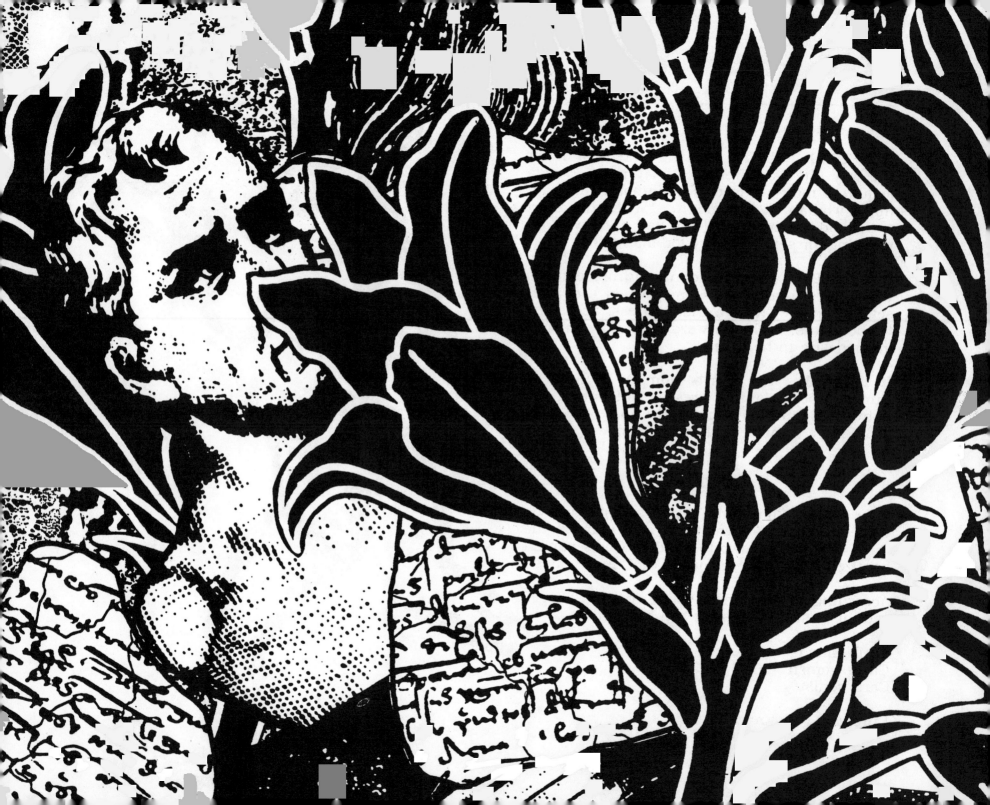

dis•cov•er

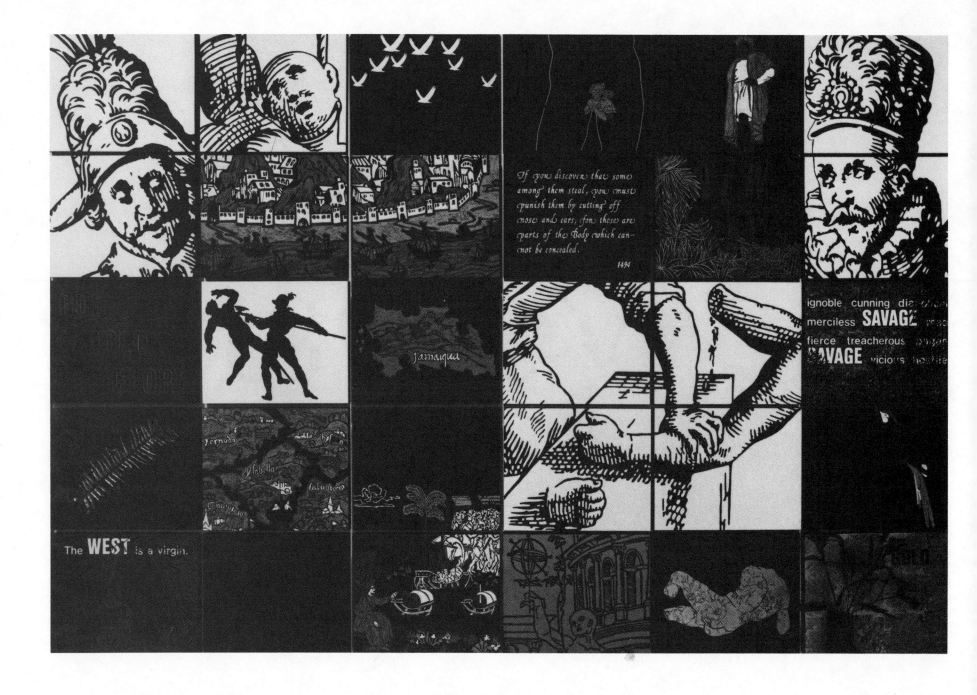

his **indomitable** will

his **fierce** determination

his **undaunted** courage

his **insatiable** curiosity

his **single-minded** devotion

his **unwavering** resolve

his **audacious** vision

his **adventurous** spirit

his **stubborn** persistence

his **remarkable** perseverance

his **fervent** dedication

his **imaginative** boldness

his **heroic** ambition

his **unshakeable** confidence

his **passionate** longing

his **navigational** prowess

his **consummate** seamanship

his **unparalleled** skill

his **persuasive** powers

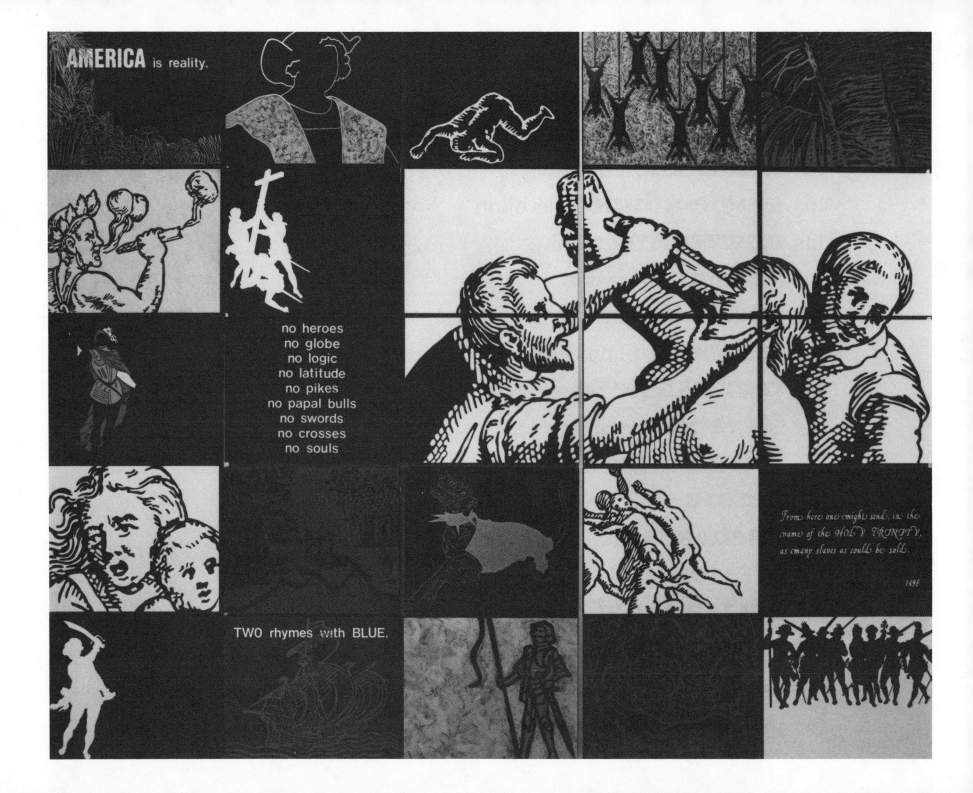

his **vast** ambition

his **impassioned** nature

his **boundless** imagination

his **obstinate** assurance

his **burning** faith

his **missionary** zeal

his **enterprising** boldness

his **eloquent** simplicity

his **inspiring** self-discipline

his **exalted** ideals

his **stoic** endurance

his **selfless** devotion

his **noble** purpose

his **devout** self-sacrifice

his **daring** inspiration

his **ardent** enthusiasm

his **divine** impulse

his **solemn** renunciation

his **creative** intuition

TAINO

There was then no sickness.
We had then no aching bones.
We had then no high fever.
We had then no small pox.
We had then no burning chest.
We had then no abdominal pain.
We had then no consumption.
We had then no headache.
At that time the course of humanity
was orderly. The foreigners made it
otherwise when they arrived here.

From the Maya book, *Chilam Balam of Chumayel,*
referring to the time before the invasion
of the Europeans

amoebic dysentery
bloody flux
bubonic plague
catarrh
chicken pox
cholera
consumption
dengue fever
diphtheria
influenza
malaria
measles
mumps
pleurisy
pneumonia
scarlet fever
small pox
scrofula
tuberculosis
typhoid fever
typhus
yellow fever

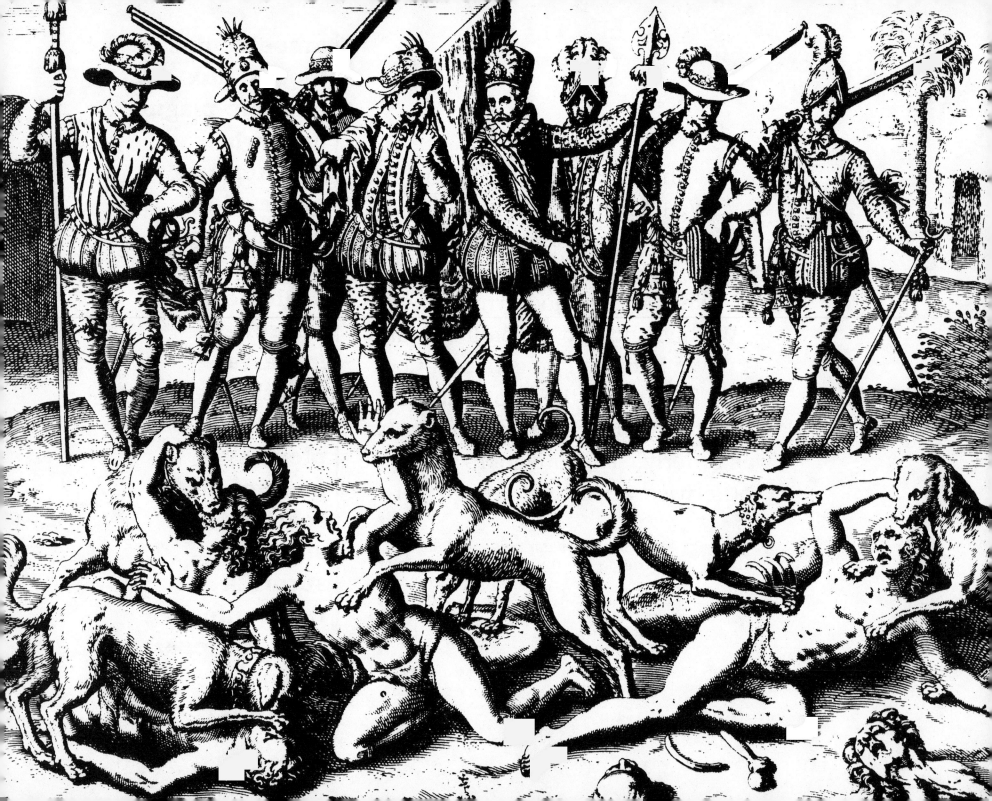

INDIANS, AMERICAN:

arts of
bestial character ascribed to
color of
conversion of, *see* conversion, religious
"cowardice" of
diseases contracted by
enslavement of
extermination of, *see* **gen•o•cide**
idealization of
identification with
internal dissension among
as interpreters
known cultures compared to
languages of
Latin learned by
nakedness of
nascent Christianity seen in
as objects
official protection of
private property and
punishment inflicted on
religion of, *see* religions, Indians
self-determination proposed for
utopian vision of
veracity of
see also specific tribes

From the index of *The Conquest of America*, 1982,
Tzvetan Todorov

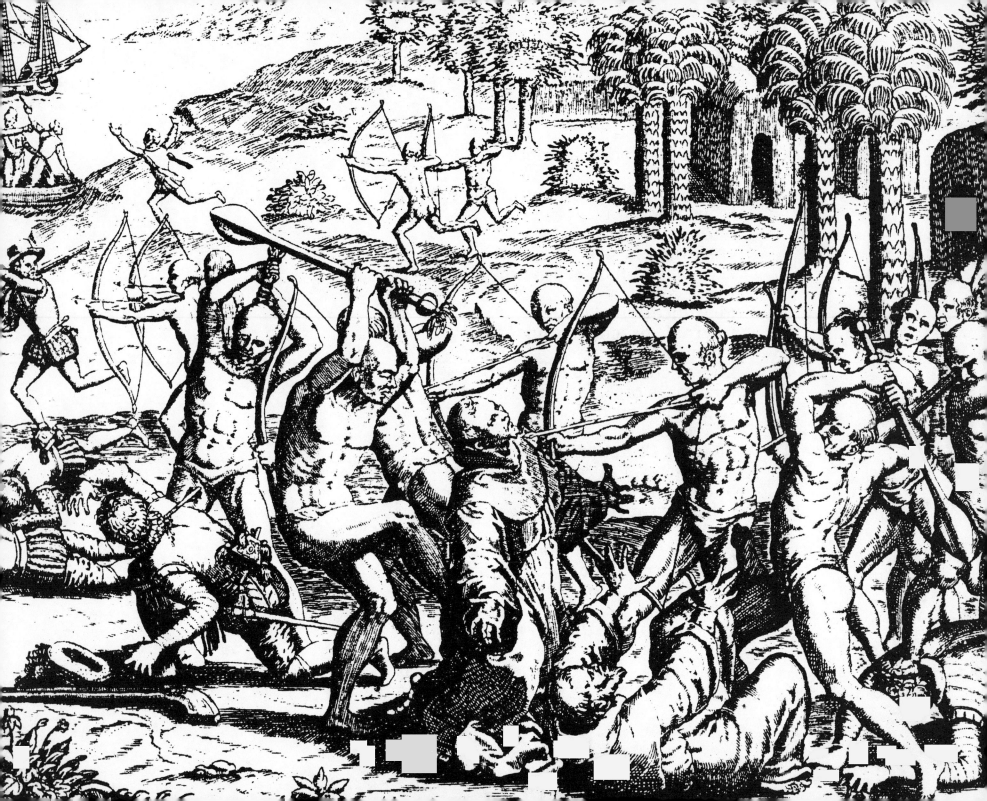

CARIB

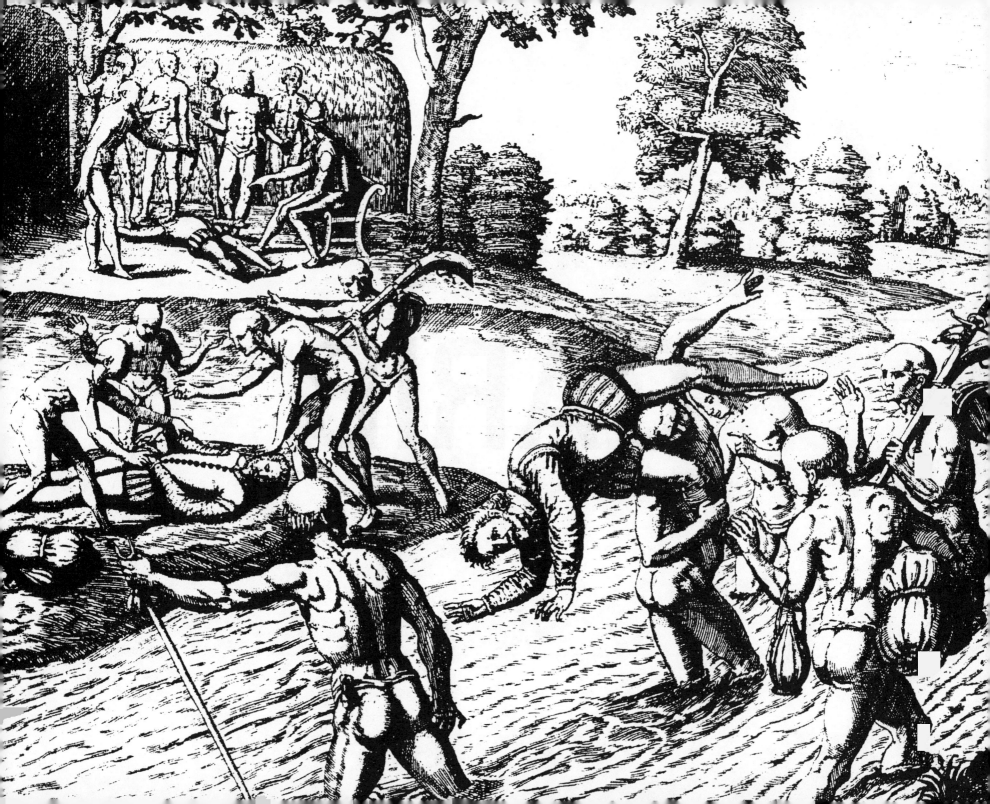

"When the Spaniards first went to conquer the island they call San Juan de Porto-rico on account of the abundance of gold and silver found there, the Indians believed that they were immortal.

"A certain chief decided to put the matter to the test and ordered his men to seize a Spaniard who was lodging in his house, carry him to the river, and then hold him under water so long that if he was mortal he would be drowned. Having thus drowned him, they carried him back on their shoulders to their master, who, seeing that he was dead, considered that all the others must also be mortal.

"Thus he concerted a revolt with the other chiefs who had suffered ill-treatment from the Spaniards. They killed about a hundred and fifty who were dispersed about the island seeking gold and had not Diego Salazar arrived with reinforcements the Spaniards would have been cut to pieces to a man."

From *La Historia del Mondo Nuovo*, 1565,
Girolamo Benzoni

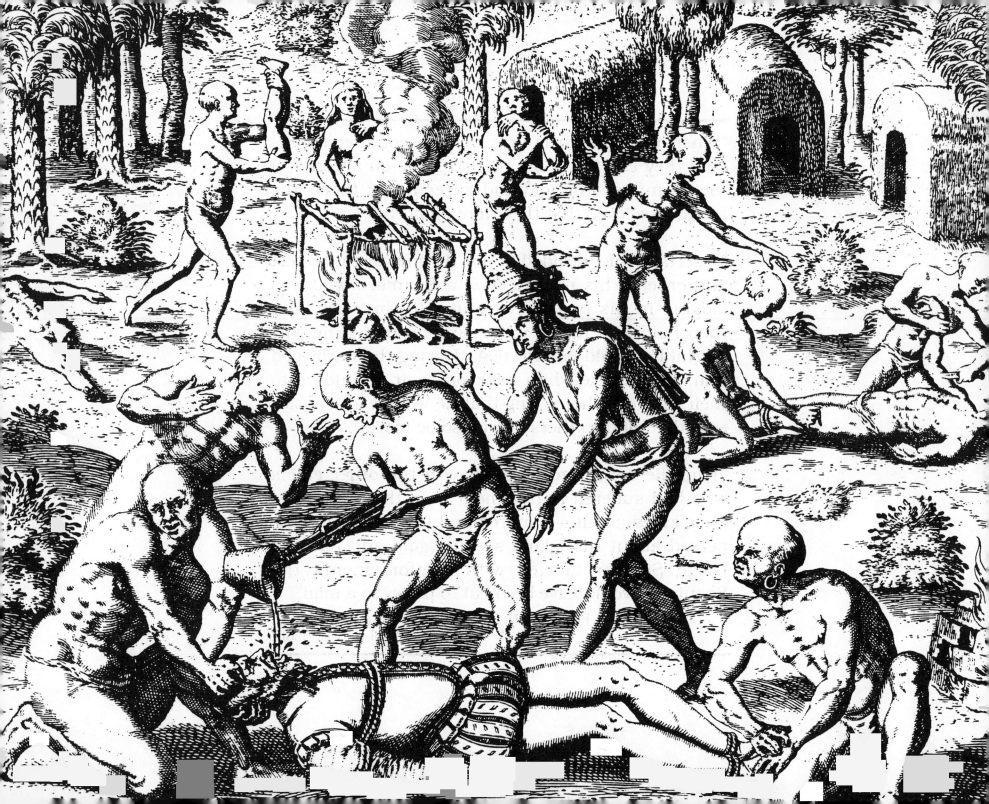

eat • christian • gold

Those they caught alive,
in particular the captains,
they used to tie up by
their hands and feet.
Then they would throw them
to the ground and pour
molten gold into their mouths saying,
**"Eat, eat gold,
Christian."**

From *La Historia del Mondo Nuovo*, 1565,
Girolamo Benzoni

hell • heaven • hell

When the cacique Hatuey is tied to the
stake, a Franciscan attempts to
persuade him to convert to Christianity.

The friar explains to the cacique that if
his soul is saved, he will go to heaven
and be spared the eternal torments of
hell.

Hatuey asks if there are any
Spaniards in
heaven.

Assured by the friar that there are,
Hatuey replies: I prefer
hell.

From *Brief Account of the Devastation of the Indies*, 1542,
Bartolomé de Las Casas

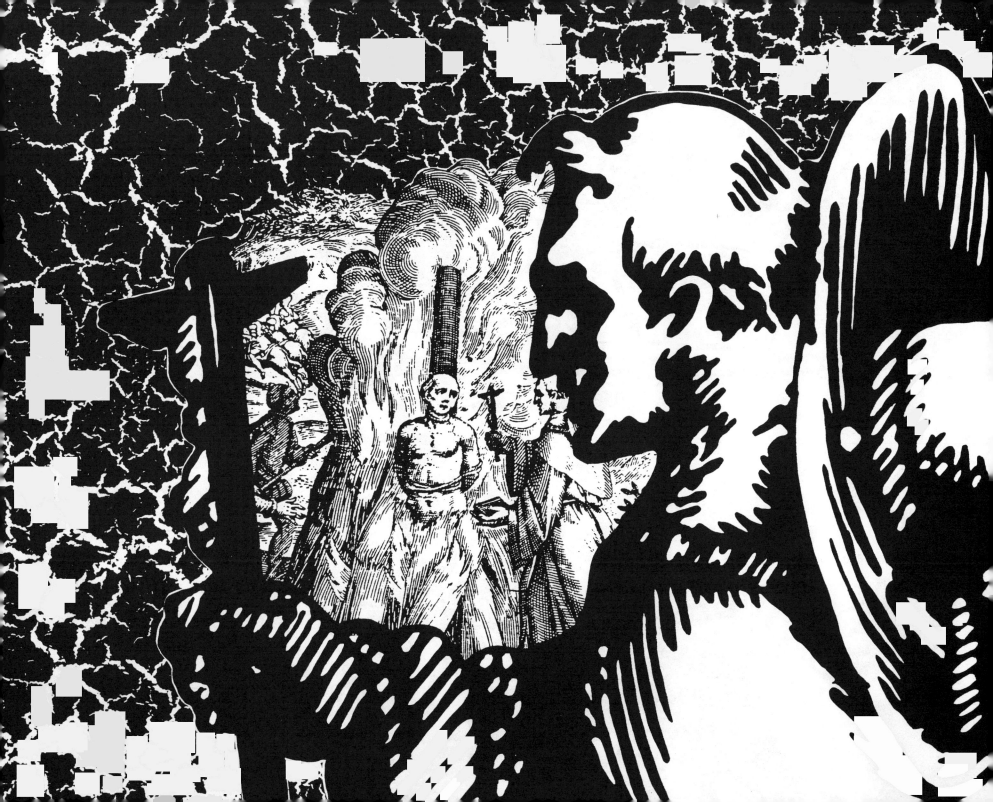

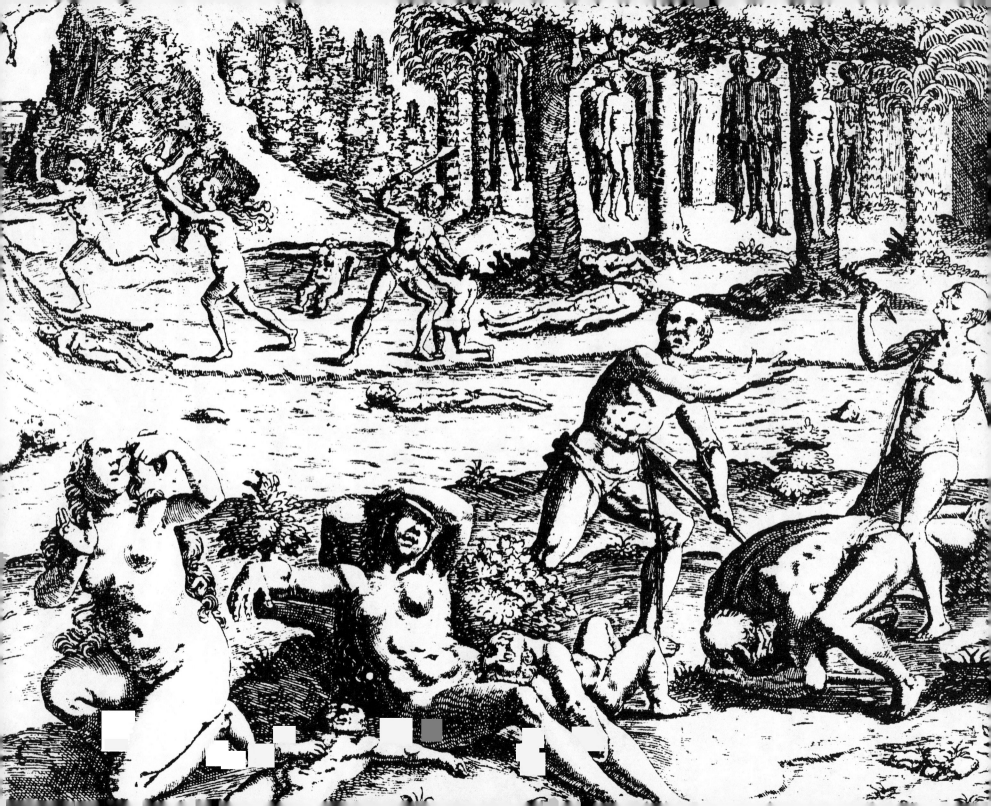

"After the death of Columbus, other governors were sent to Hispaniola, both clerical and secular, till the natives, finding themselves intolerably oppressed and overworked, with no chance of regaining their liberty, with sighs and tears longed for death. Many went into the woods and having killed their children, hanged themselves, saying it was far better to die than to live so miserably serving such ferocious tyrants and villainous thieves. The women terminated their pregnancies with the juice of a certain herb in order not to produce children, and then following the example of their husbands, hanged themselves. Some threw themselves from high cliffs down precipices; others jumped into the sea and rivers; others starved themselves to death.

"Finally, out of two million inhabitants, through suicides and other deaths occasioned by the excessive labor and cruelties imposed by the Spaniards, there are not a hundred and fifty now to be found."

From *La Historia del Mondo Nuovo*, 1565,
Girolamo Benzoni

...el R...e la Regina de Spagna ...

...rabile che in essa se contengono ...a ...

...stra Italica lengua: e voler ...

...uni mei amici: che cum grand ...

...como anchora per fare cosa ...

...de cose noue: e degne da ...

...a sua Magnificentia la qual ...

...e predertim noue: quale questa ...

...nchora per monstrarli lamore m...

...eficij soi in me como per le grar d...

...a. Quale historia se piu longa fo...

...agnificentia dedicata. Ma a ...

...con qu... ...Verum e ijo l...te rustici...

god•church•king

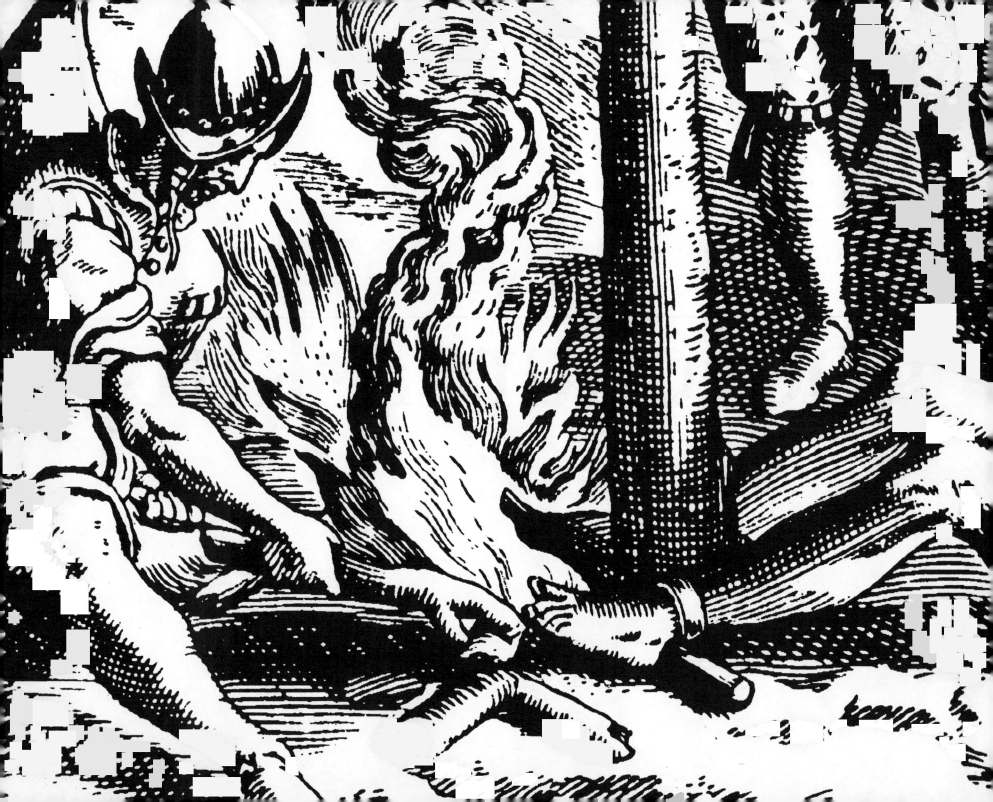

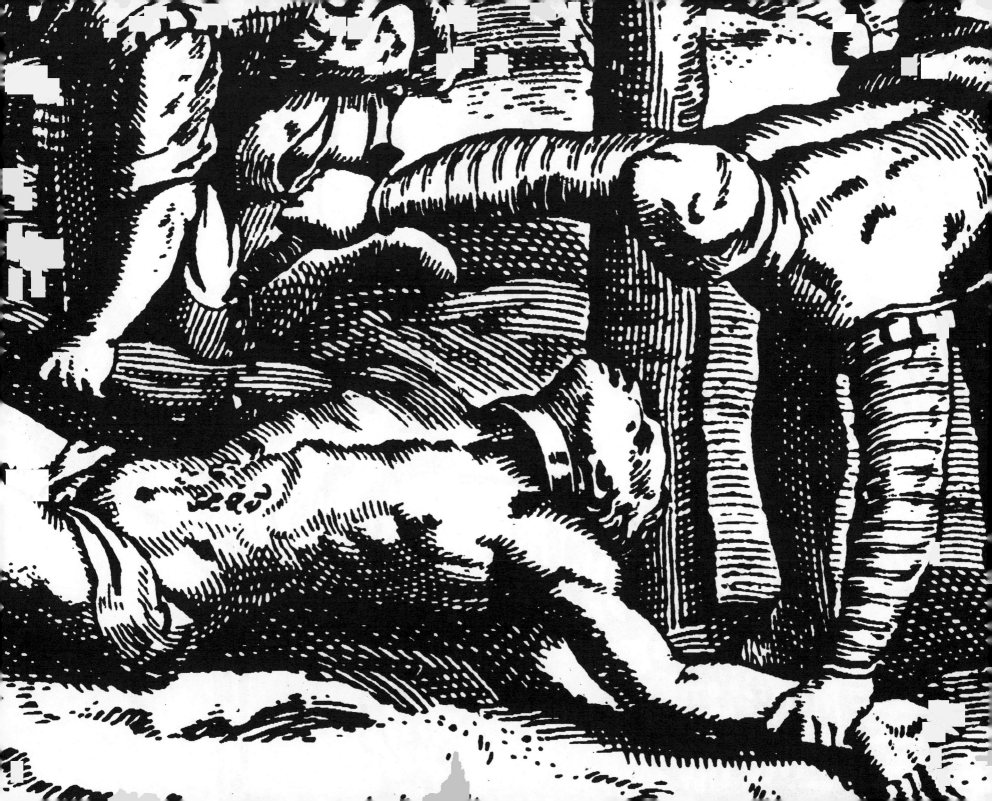

FATHER BARTOLOMÉ
Maggie Jaffe

*1. **1502.** Savage natives, untamed jungle.*
*2. **1514.** Savage but possessing souls.*
*3. **1515.** Conquistadors are in fact the savages.*

1.

Bartolomé de Las Casas
believes in
KING, CHURCH, GOD.
Though the sextant tilts
crazily he won't fall
off his watercourse
to bless the New
World's "gentle people,"
sweat-choked jungle,
thin-aired sierras, coral reef.

Never has he seen an Indian:
"man-eating" Carib
"dog-faced" Tupinamba
"war-fierce" Florida sodomite
"excrement-eating" Palma
"child-like" Arawak
"time-obsessed" Mexica
Maya, inventor of zero.

2.

Do they possess souls.
Yes they do.
Thereupon he frees his Indians

but retains his African: "pitch-
black, sturdy and slavish . . ."

The King agrees.
If not for Africans who will work
the fields, the mines?
Later he repents.

*No body should
be shackled to the rich
New World's earth:*
CHURCH, GOD, KING.

3.

Compulsive scribbler
to the King, he writes
that spring, 1515:
torture, hanging,
Indians-as-dog-meat,
death by slow burning, rape,
gold disease:

*Conquistadors stretch their bodies
between two branches of a tree
and place burning logs beneath
their feet. And a boy, with a swab*

*of oil, sprinkles their soles.
They continue to be tortured
until the bone marrow comes out.*

Alone, his make-shift study,
quilled, papered: jungle
moisture makes ink bleed.
*I won't stopper myself
unless the butchering stops.*

Now the ghosts of millions
obsess him. Why were they
murdered? Because
they are naked,
"three-fourths human,"
more numerous than birds,
disrespectful to gold.

Yet Las Casas's faith is intact
in spite of Hell carved out
with the cross-
bow, branding iron, rivers
of native blood.

Still, *he*
(GOD, CHURCH, KING)
doesn't see it that way.

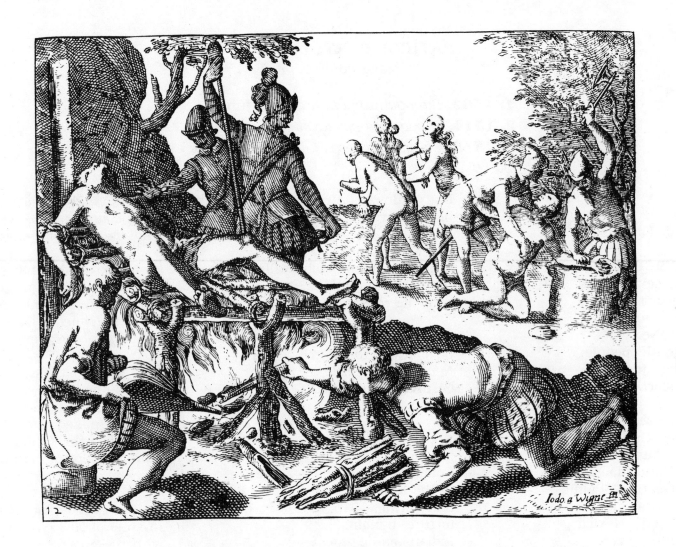

Iodo. a Wigur. ſt.

Hac morte communiter Dominos, & Nobiles mulcta-
bant. Perticis furca ſuffultis craticulas ſtruebant, paruoq́; igne
ſuppoſito, hi miſeri paulatim, animam, magnis clamoribus, tor-
mentorumq́; deſperatione, efflabant.

Vidi aliquando quatuor, aut quinque ex potentioribus
Dominis, his craticulis impoſitos torreri; & non procul duę, vel
tres aliæ craticulæ, ijſdem mercibus inſtructæ viſebantur; cum-
que ma-

"They made some low wide gallows on which the hanged victim's feet almost touched the ground, stringing up their victims in lots of thirteen, in memory of our Redeemer and His twelve Apostles, then set burning wood at their feet and thus burned them alive.

"To others they attached straw or wrapped their whole bodies in straw and set them afire. With still others, all those they wanted to capture alive, **they cut off their hands** and hung them round the victim's neck, saying 'Go now, carry the message,' meaning, 'Take the news to the Indians who have fled to the mountains.'

"They usually dealt with the chieftains and nobles in the following way: they made a grid of rods which they placed on forked sticks, then lashed the victims to the grid and lighted a smouldering fire underneath, so that little by little, as those captives screamed in despair and torment, their souls would leave them.

"And because all the people who could do so fled to the mountains to escape these inhuman, ruthless, and ferocious acts, the Spanish captains, enemies of the human race, pursued them with the fierce dogs they kept which attacked the Indians, tearing them to pieces and devouring them. And because on few and far between occasions, the Indians justifiably killed some Christians, the Spaniards made a rule among themselves that for every Christian slain by the Indians, they would slay a hundred Indians."

From *Brief Account of the Devastation of the Indies*, 1542,
Bartolomé de Las Casas

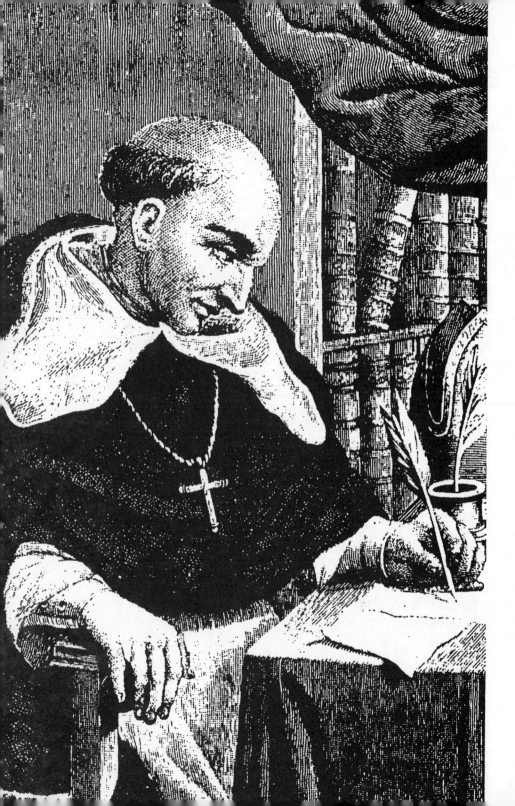

APOSTLE • OF • THE • INDIANS

I

It is 1493. Eighteen-year-old Bartolomé de Las Casas watches as Columbus parades his parrots, gold, and newly discovered Indians down the streets of Seville after his triumphant return from the First Voyage to the "New World."

It is 1498. Las Casas's father, who accompanies Columbus on his Second Voyage to the "New World," returns to Seville with a Taino Indian slave.

It is 1502. Las Casas travels to the "New World" for the first time with the newly appointed governor of Hispaniola, Nicolás de Ovando. There, Las Casas receives a *repartimiento*, a land grant, and the right to use Indian labor.

II

It is 1511. "Are these Indians not men?" Dominican friar Antonio de Montesinos asks. "Do they not have rational souls? Are you not obliged to love them as you love yourselves?"

It is 1514. A Spanish official reads the *Requerimiento* to the Indians. Spanish law decrees that this judicial declaration must be read to the Indians before any hostilities against them can commence. Many of the

Indians do not understand the Spanish language. Nonetheless, the official tells them that if they submit peacefully, all will be well. But if they refuse to acquiesce to the "truths" of the *Requerimiento*, their lands will be confiscated, their bodies enslaved, their children held as hostages.

In other words, the full brute force of the Spanish empire will be mobilized against them.

"I am a voice crying in the wilderness."

III

It is 1514. Las Casas, now a Dominican priest in the "New World," renounces his gold mines and possessions and then frees his enslaved Indians.

"I thought about the misery and slavery in which the native people are living here," Las Casas writes. "And the more I thought about it the more convinced I was that everything we had done to the Indians so far was nothing but tyranny and barbarism. . . ."

It is 1515. Las Casas begins his first of fourteen journeys between the "New World" and Spain to petition the Crown and the Council of the Indies on behalf of the Indians.

It is 1516. The Spanish crown appoints Las Casas "Protector of the Indians." He has been working tirelessly on behalf of the indigenous inhabitants of the "New World" for over two years.

It is 1520. Las Casas suggests that Africans replace Indians as slaves in the "New World."

Later, Las Casas will realize the horror of his suggestion. "The priest Las Casas was the first to suggest that one should introduce Africans to the West Indies." Writing about himself in the third person in his *History of the Indies*, Las Casas accuses himself of the enormous injustice of this suggestion. "He did not know what he was doing. When he heard that the Portuguese were catching people in Africa against all laws and made them into slaves he bitterly regretted his words. . . the right of blacks is the same as that of the Indians."

It is 1555. Las Casas proposes that the King of Spain renounce his empire in the "New World": "The true remedy to all these evils . . . is to deliver the Indians from the diabolical power to which they are subject, to restore their first liberty to them"

Las Casas, an early advocate for the "peaceful" colonization of the "New World," now insists that to stop the death and destruction, Spain must return the "New World" to its original inhabitants. Las Casas finally realizes that Christianity is merely a carrot when the stick of military force must accompany the conversion of native people and the appropriation of their land. Colonialism is never a peaceful enterprise.

Pacification **is** conquest.

It is 1566. Las Casas dies working on his final manuscript, *About the Sixteen Remedies Against the Plague Which Has Exterminated the Indians.*

Later, Las Casas will be called a "malicious bishop," a "deluded churchman," and a "fanatic," as well as a "pigheaded anarchist," a "preacher of Marxism," and a "dangerous demagogue."

It is 1991. No one knows where Las Casas is buried. In his introduction to Las Casas's *Brief History of the Devastation of the Indies*, Hans Magnus Enzensberger notes that in Spain, there are no monuments to the memory of the official "Protector of the Indians."

IV

It is 1866. Las Casas, officially known as the "Protector of the Indians," is also unofficially known as the "Apostle of the Indians." Three hundred years after the Apostle dies, the Vatican begins beatification proceedings, but not for Las Casas. Christopher Columbus is their candidate for potential sainthood. In the Vatican's providential interpretation of history, it is Columbus who is chosen by God to discover a "New World" and to spread His word.

It is 1819. Simón Bolívar, the Liberator, proposes that the new revolutionary republic be called Colombia and its capital Las Casas to honor both men.

Later, Colombia will indeed be named Colombia, after Columbus, but its capital will be named Bogotá, not Las Casas as Bolívar proposed.

It is 1891. One year before the quatercentenary of the "discovery," Columbus's beatification proceedings grind to a halt. The Vatican cites two reasons why Columbus cannot be beatified: first, he had a mistress, Beatrice de Harana; and second, the irrefutable fact that Columbus introduced slavery in the "New World." People elevated to sainthood do not overtly support the enslavement of one group of people by another.

It is 1891. In the Church tribunal's final deliberation, only one vote is cast in favor of Columbus's beatification. The next year, however, Columbus Day is declared an official U.S. holiday.

It is 1988. "If they need a saint, they should canonize Bartolomé de Las Casas," Ed Castillo, a Cahuilla Indian and historian, tells the audience at a colloquium discussing the recent beatification of Junipero Serra and his role as founder of the California Missions—a system of forced labor, forced conversion, and confinement. The Vatican beatifies Serra in spite of the strong opposition of many descendants of the "mission" Indians and others.

It is 1991. The San Diego County Christopher Columbus Quincentenary Commission hosts a gala reception at the Junipero Serra Museum.

V

It is 1550. In the great debate at Vallodolid in Spain between Las Casas and Ginés de Sepúlveda, the latter uses Aristotle's doctrine of natural slavery to justify the enslavement of Indians "in whom you will scarcely find even vestiges of humanity." Some men are fit to rule, others are born to be slaves.

"How can we doubt that these people, so **uncivilized**, so **barbaric**, so **contaminated** with so many sins and obscenities have been justly conquered. . . ."

Sepúlveda knows his Aristotle, but he doesn't know any Indians.

VI

It is 1550. The debate continues. Sepúlveda argues that one Indian soul saved is worth many destroyed: "The loss of a single dead soul without baptism exceeds in gravity the death of countless victims, even were they innocent." Sometimes we have to destroy the savages in order to save them.

Las Casas, on the other hand, argues that it is worth nothing to baptize an Indian if in doing so that Indian must be destroyed.

"It would be a great disorder and a mortal sin," he writes, "to toss a child into a well in order to baptize it and save its soul, if thereby it died."

VII

It is 1769. In Alta California, Franciscan Junipero Serra, a "Sepúlvedean," baptizes Indian infants moments before they die. Because of a widespread epidemic, "the Fathers were able to perform a great many baptisms . . . sending a great many children . . . to Heaven." This epidemic, and others that follow, are brought to California by the Franciscans and the Spanish soldiers.

It is 1989. Even staunch promoters of Serra's canonization will concede that Serra, like Columbus, was a "man of his time." The virtues of sainthood, however, are timeless.

At the end of his life, Las Casas argues to return the land to its rightful caretakers, the Indians. Las Casas was considered "ahead" of his time. Ahead, perhaps, of **our** time.

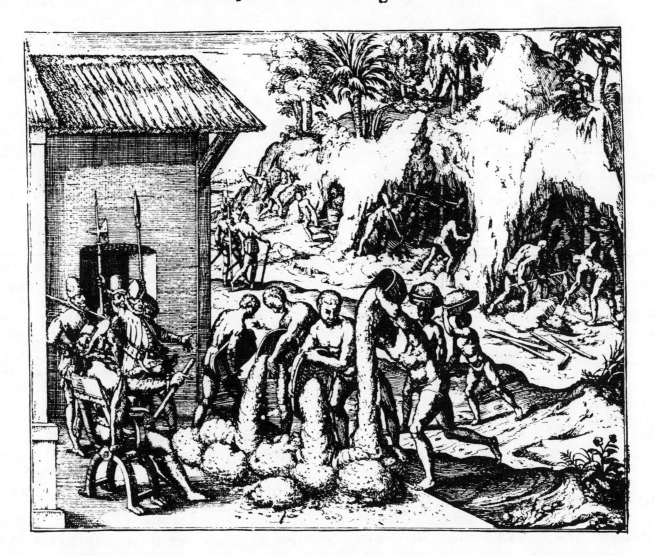

Ttritis, & penè absumptis continuo labore Hispaniolæ Insulæ incolis, Hispani aliunde man-
cipia conquirere cœperunt, quorum ministerio in perfodiendis montibus, venisque metal-
licis perscrutandis vterentur. Itaque redemptis sua pecunia, & accitis ex Guinea Quartæ
Africæ partis Prouincia mancipijs æthiopibus siue Nigritis; illorum porrò opera vsi sunt,
donec temporis successu quidquid in ea Insula metallicarū venarū inesset, exhaurirent. Nam vt Lusitani
eam Africæ partem quam ipsi Guineam (Incolæ Genni aut Genna appellant) sibi
subiectam reddiderant ; singulis annis aliquot incolarum centurias
exteris nationibus diuendebant , quæ mancipiorum
vicem supplerent.

"When the natives of Hispaniola began to be extirpated, the Spaniards provided themselves with blacks from Guinea. . . . When there were mines they made them work at extracting gold and silver; but since those came to an end they have increased the sugar works and it is in this industry and in tending the flocks and in the general service of their masters that they are chiefly occupied. Some of the Spaniards were not only cruel, but very cruel. If a slave had committed some crime, or had not done a good day's work, or had failed to extract the usual quantity of gold or silver from the mine, he might be severely punished. . . .

"Thus, on account of these very great cruelties, some of them escaped from their masters and wandered the island in a desperate state. . . .

"But in the end the negroes learned to keep watch and be very vigilant whereby the Spaniards often got the worst of it. Thus the blacks have become so fierce and numerous that when I was residing on the island it was asserted that there were upwards of seven thousand. And in the year '45, while I was there, it was reported that the *Cimaroni* (for so the Spaniards in those countries call the outlaws) had joined a general rebellion and were rampaging all over the island and doing all the mischief they could. Many Spaniards prophesy for certain that the island in a short time will fall entirely into the hands of these blacks."

From *La Historia del Mondo Nuovo*, 1565,
Girolamo Benzoni

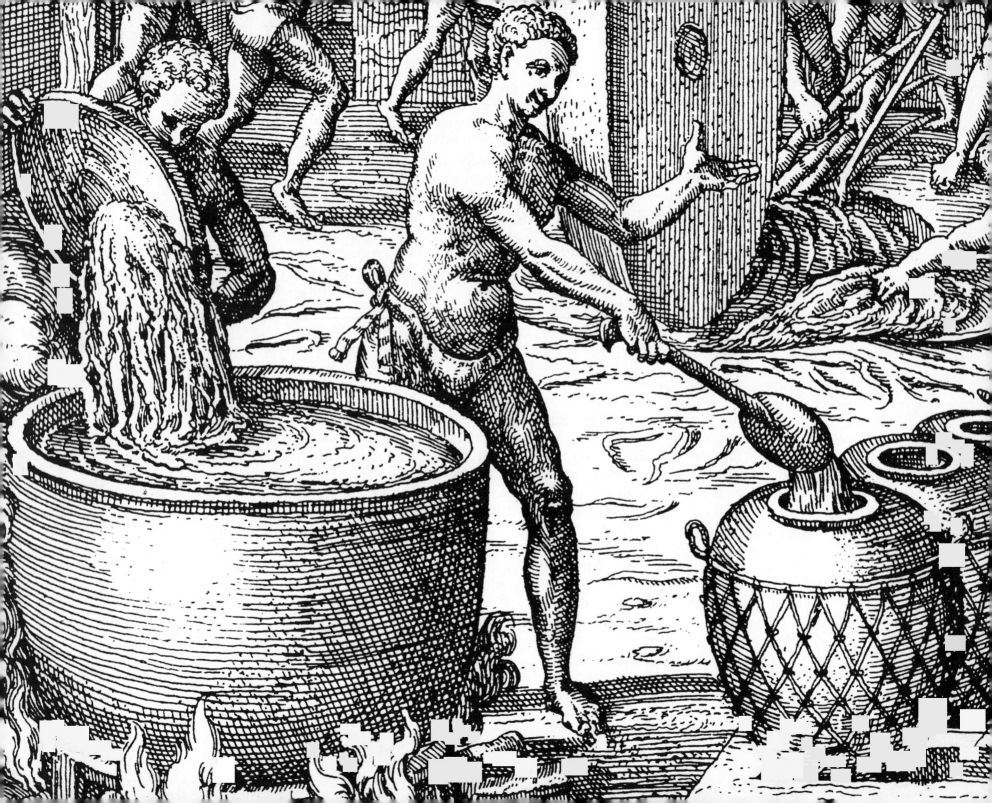

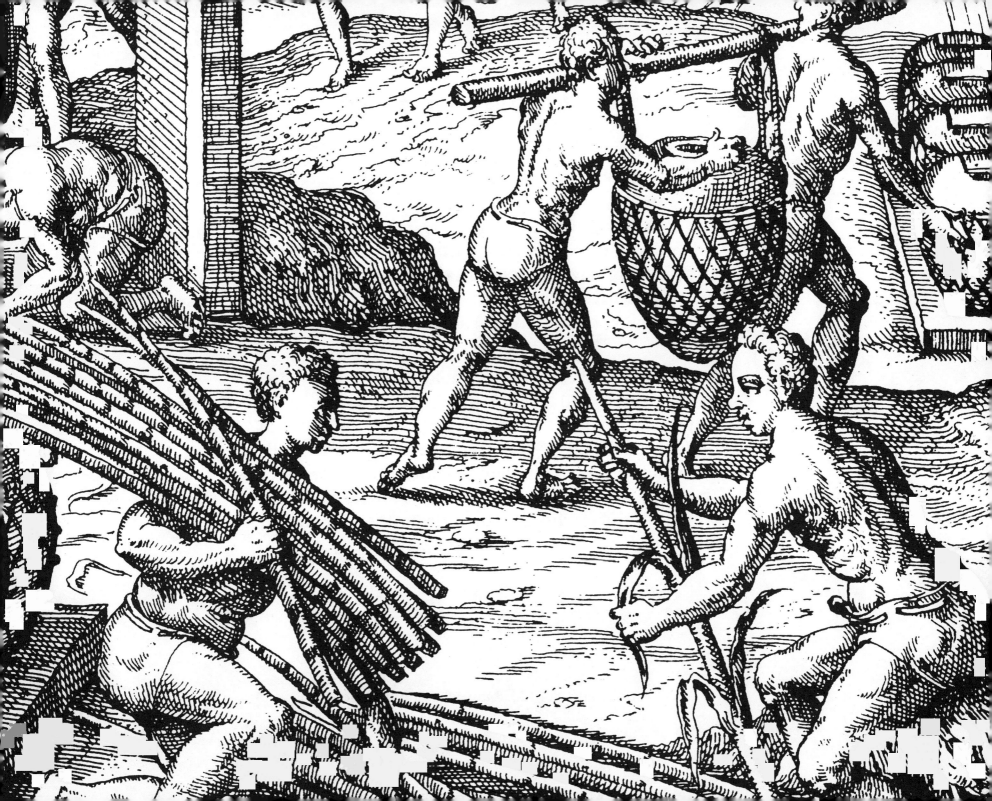

empty • empyre • enterprise

". . . the Archive of the grandest enterprise ever undertaken by a nation: **discovering, conquering, evangelizing, colonizing, humanizing,** and **populating** an empty and silent continent, from pole to pole and from sea to sea.

"The cases and shelves . . . hold thirty-eight thousand papers and documents, including the most important *Diary of Columbus* and the *Mapa Mundi* of Juan de La Cosa—the narrative and graphic birth certificate of America—which contain the names of the conquerors of the sea . . . of the ambassadors of Christ, of those who gave their flesh, their blood and their word to fill an empty, silent continent"

From *Seville*, 1970, Manuel Bendala Lucot

Nootka Ottawa Squawmish Mashpee Nantucket Narraganse Niantic Nono... Wabaq
...sset Massapequa Rockaway Secatogue Chattahoochee Crotoan Raritan Roanoke Secota
..e Woccon Seminole Calusa Potawatomi Miami Sauk Foxes Winnebago Onondaga Cayu
.. Nipmuc Wampenoag Squamscot Wachuset Winnecowet Massachusett Pequot Yanktona
..n Omaha Iowa Ponca Oglala Brule Teton Arikara Sisseton Minniconjou Kickapoo Ka
..oni Tawehash Kiowa Anadarko Nasoni Osage Little Osage Quapaw Mosopelea Missour
..w Biloxi Pascagoula Chawasha Chitimacha Caddo Nacogdoches Pawnee Oto Moingwen
..ampo Tuskegee Modoc Comanche Delaware Shawnee Pottawatomie Potomac Rappaha
..hominy Yadkin Catawba Yamasee Suquamish Chelan Spokan Palouse Cayuse Snake
..ck Skilloot Skokomish Wynoochee Satsop Ohlone Wiyot Chepeneafa Taltushtuntude Pi
..ook Yakima Chinook Hainai Tuscarora Chiricahua Apache Mescalero Apache Jicarilla A
..ne Arapaho Ute Blackfeet Crow Flathead Nez Perce Northern Shoshoni Bannock North
..s Havasupai Kaibab Assiniboin Gros Ventre Piegan Algonkin Bellabella Bellacoola Ojib
..a Huron Iroquois Niska Nootka Ottawa Squawmish Mashpee Nantucket Narragansett
..uasset Canarsee Manhasset Massapequa Rockaway Secatogue Chattahoochee Crotoan
..cock Wando Wimbee Woccon Seminole Calusa Potawatomi Miami Sauk Foxes Winneb
.. Tuscarora Oneida Nipmuc Wampenoag Squamscot Wachuset Winnecowet Massachuse
..n Santee Yankton Omaha Iowa Ponca Oglala Brule Teton Arikara Sisseton Minnicon
..a Waco Tawakoni Tawehash Kiowa Anadarko Nasoni Osage Little Osage Quapaw Mos
..waw Choctaw Biloxi Pascagoula Chawasha Chitimacha Caddo Nacogdoches Pawnee O
..amea Kaskinampo Tuskegee Modoc Comanche Delaware Shawnee Pottawatomie Potom
..eake Chickahominy Yadkin Catawba Yamasee Suquamish Chelan Spokan Palouse Cay
..th Bannock Skilloot Skokomish Wynoochee Satsop Ohlone Wiyot Chepeneafa Taltusht
.. Tillamook Yakima Chinook Hainai Tuscarora Chiricahua Apache Mescalero Apache Jico
..ne Arapaho Ute Blackfeet Crow Flathead Nez Perce Northern Shoshoni Bannock North
..s Havasupai Kaibab Assiniboin Gros Ventre Piegan Algonkin Bellabella Bellacoola Ojib
..a Huron Iroquois Niska Nootka Ottawa Squawmish Mashpee Nantucket Narragansett
..uasset Canarsee Manhasset Massapequa Rockaway Secatogue Chattahoochee Crotoan
..cock Wando Wimbee Woccon Seminole Calusa Potawatomi Miami Sauk Foxes Winneb
.. Tuscarora Oneida Nipmuc Wampenoag Squamscot Wachuset Winnecowet Massachuset
..n Santee Yankton Omaha Iowa Ponca Oglala Brule Teton Arikara Sisseton Minnicon
..a Waco Tawakoni Tawehash Kiowa Anadarko Nasoni Osage Little Osage Quapaw Mos
..waw Choctaw Biloxi Pascagoula Chawasha Chitimacha Caddo Nacogdoches Pawnee O
..amea Kaskinampo Tuskegee Modoc Comanche Delaware Shawnee Pottawatomie Potom
..eake Chickahominy Yadkin Catawba Yamasee Suquamish Chelan Spokan Palouse Cay
..th Bannock Skilloot Skokomish Wynoochee Satsop Ohlone Wiyot Chepeneafa Taltusht
.. Tillamook Yakima Chinook Hainai Tuscarora Diegueno Cupeno Luiseno Gabrielino Cah
.. Kohuana Yuma Paipa Kikima Serrano Nicoleno Chumash Salinan Esselen Yokuts Co

empyre

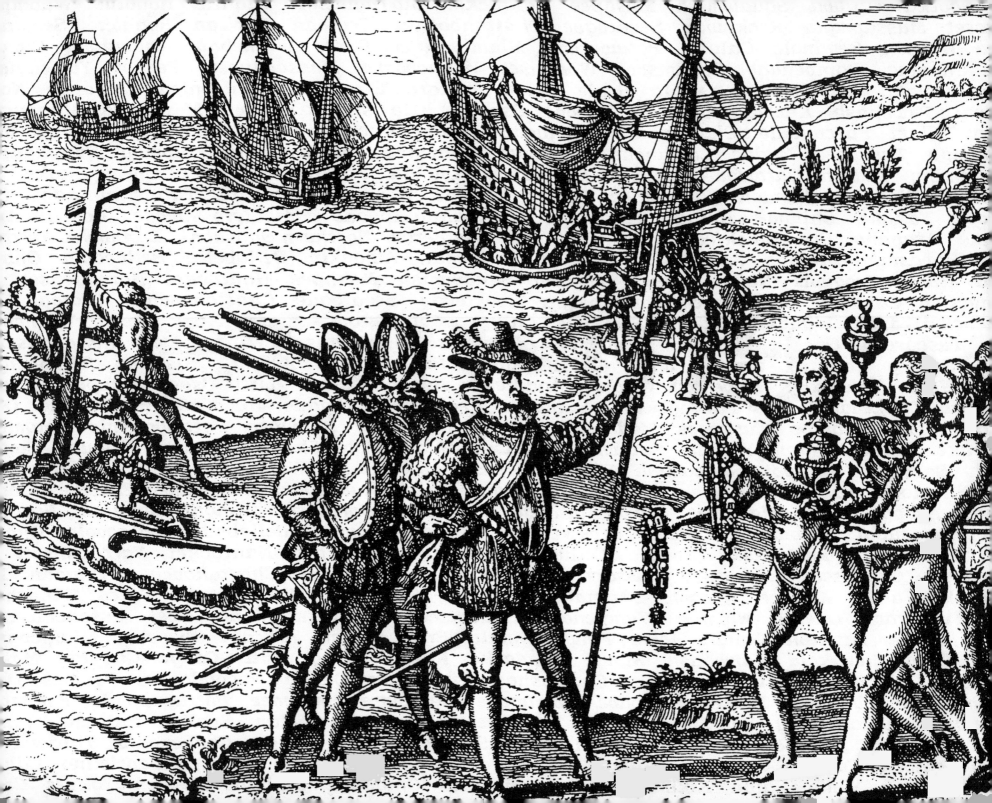

no maps
no charts
no longitudes
no latitudes
no sails
no masts
no mariners
no logs
no astrolabes
no compasses
no sextants
no tradewinds
no doldrums
no hourglasses
no equations
no telescopes
no quadrants
no scales
no caravels
no coat of arms
no navigators
no banners
no flags

no history
no heroes
no diaries
no journals
no chronicles
no treaties
no contracts
no laws
no letters
no logic
no numbers
no Ptolemy
no Marco Polo
no accounts
no archives
no annals
no manuscripts
no pens
no parchment
no quills
no Latin
no chapters
no verse

NEW • WORLD • ORDER

It is 1991. "We have before us the opportunity to forge for ourselves, and for future generations, a New World Order," Great White Father George Bush tells his television audience shortly after he orders the relentless bombardment of Iraq to begin, "a world where the Rule of Law, not the Law of the Jungle, governs the conduct of Nations."

It is 1893. One hundred years before the dawning of the New World Order, the World's Columbian Exposition opens in Chicago to celebrate the quatercentenary of Columbus's "discovery" of the "New World."

It is 1893. For the Exposition, Albert Bierstadt, grandiloquent painter of the American "wilderness," completes three versions of *The Landing of Columbus*. In version #3, Columbus is bathed in full sunlight and basks in the glories of the imperial invasion about to commence in the "New World." He gazes skyward, banner held aloft in left hand, sword in right.

It is 1893. In Bierstadt's version #3, several soon-to-be-called "Indians" have rushed to the beach to kneel before the obviously superior nonIndians disembarking on their sunlit shores. Other Indians lurk in the shadows of the jungle-like foliage that frames the left half of the painting.

It is 1892. While Bierstadt is busy painting his triumphant and celebratory canvas, John

Muir founds the Sierra Club to preserve what is left of the North American "wilderness."

It is 1847. John Vanderlyn's painting, *Columbus Landing,* is installed in the Capitol Rotunda. Anticipating Bierstadt's depiction, Vanderlyn's Columbus assumes his usual proprietary stance and gazes skyward to receive the providential blessing for his heroic enterprise. Vanderlyn's Indians, like Bierstadt's, crouch in the bushes.

It is 1991. In the back country of the Sierra Nevada, tourists must carry a wilderness permit to hike or camp.

It is 1991. Vanderlyn's epic painting is widely reproduced in children's history books. It also was reproduced on the cover of a new mini-version of Samuel Eliot Morison's two-volume, Pulitzer Prize-winning biography of Columbus, *Admiral of the Ocean Sea.* The mini-version accompanied a 1986 CBS mini-series about Columbus, starring Faye Dunaway as Queen Isabella.

It is 1949. In another movie version of *Christopher Columbus*, starring Fredric March as The Great Navigator, Columbus stands on the edge of the "New World" frontier. Once again, he gazes skyward. Once again, he claims the land for Spain, names the island San Salvador, and declares that the natives are subject to Spanish rule. One Indian lays down his weapon and kneels before Columbus. Like Bierstadt's and Vanderlyn's Indians, these filmic nonEuropeans immediately know that they are in the presence of a rational, enlightened, and obviously superior culture.

It is 1892. To commemorate the quatercentenary, the socialist Edward Frances Bellamy composes the Pledge of Allegiance: *I pledge allegiance to my flag, and to the Republic for which it stands, one nation, indivisible, with liberty and justice for all.*

It is 1788. Frederick Kemmelmeyer paints the *Landing of Christopher Columbus.* In the foreground, Columbus, sword in right hand, points to a group of Indians clustered on the shore. One of the Indians, on hands and knees, offers a pineapple to the Europeans. The Europeans, it turns out, like the taste.

It is 1839. John Vanderlyn visits the island of San Salvador to make botanical studies for *The Landing of Columbus.* He wants to faithfully capture the luxuriant tropical flora of the "New World."

It is 1859. Bierstadt travels west to make studies for his paintings. In his own account of his travels, he writes that the Indians are "appropriate adjuncts to the scenery."

It is 1859. While Bierstadt is making sketches of scenery and Indian adjuncts, Darwin's *The Origin of Species* is published.

It is 1988. Great White Father George Bush embraces the Pledge of Allegiance as **the** emblem of Americanism in his presidential campaign. Bush overlooks the fact that the Pledge was composed by Bellamy, a socialist whose ideology any good neo-Social Darwinist should despise.

It is 1859. Bierstadt, a member of the nostalgic Before-They-Bite-The-Dust school of Indian painting, writes in his journal: "Now is the time to paint them for they are rapidly passing away and soon will be known only in history."

It is 1986. In the CBS mini-series, Columbus lands in the "New World," ever present banner in left hand, sword in right. Once again, he gazes skyward. Once again, imperial expansion is divinely sanctioned.

It is 1986. "Call it mysticism if you will," Great White Father Ronald Reagan tells us. "I have always believed there was some divine providence that placed this great land here between the two great oceans, to be found by a special kind of people"

It is 1991. Great White Father George Bush, along with Reagan, is a founding member of the Sound-Bites-R-Us school of providential and self-righteous political rhetoric. Bush, gazing skyward at the American flag, frequently expresses the belief that his kinder/gentler New World Order is divinely sanctioned.

It is 1954. The words "under God" are added to the Pledge. The same year the Supreme Court rules that separate is **not** equal, in order for the "liberty and justice for all" promise of the Pledge to become a reality.

It is 1986. In the CBS mini-series, the Indians bow down before Columbus and his men. Somehow, these prostrated Indians sense that the nonprostrated nonIndians looming over them have embarked on a holy mission to colonize, evangelize, and humanize a friendly but obviously inferior people—to wit, themselves.

Later these Indians depicted as prostrated or hiding before the Europeans will become the inscrutable foe lurking behind every rock and tree, and the obstacles in the path of westward expansion. It will become necessary to eliminate the indigenous inhabitants in order for America to fulfill its Manifest Destiny, for the rule of law to replace the law of the jungle.

It is 1892. Four hundred years after Columbus claims the "New World" for Spain, a presidential proclamation "opens" three million acres of Arapaho and Cheyenne land to "settlement."

It is 1893. Historian Frederick Jackson Turner delivers his paper, "The Significance of the Frontier in American History," at the Columbian Exposition. Turner asserts that the frontier is "the meeting point between savagery and civilization" and a necessary condition for the revitalization of the nation's spirit.

Now that "hostile Indians and the stubborn wilderness" have been conquered, Turner declares that the first phase of American history is over.

It is 1893. To reinvigorate the nation's flagging spirit and to insure that the **rule of law** replaces the **law of the jungle**, commercial, territorial, and ideological expansion must continue overseas.

It is 1893. At the Columbian Exposition, tourists visit authentic reconstructions of the *Niña*, the *Pinta*, and the *Santa María*, as well as a Penobscot Indian village, a Samoan village, and an Aztec village. Exotic and ethnic "others" from all over the globe are displayed for the tourists' edification and amusement.

It is 1893. Edward Bellamy, writer of the Pledge, proposes that October 12 be set aside as a special day to commemorate Columbus's "discovery."

It is 1893. Bierstadt's Indians, like those depicted in paintings by Vanderlyn and Kemmelmeyer, will soon discover banners, trumpets, bayonets, swords, rifles, mastiff hounds, shackles, cannons—instruments designed to insure that the **rule of law**, not the **law of the jungle**, governs imperial expansion.

It is 1991. On Columbus Day children paint pictures of the *Niña*, the *Pinta*, and the *Santa María*. The children take their cue from books such as *The Value of Curiosity*, in which a large smiling sun shines benevolently on Columbus and his men as they disembark on the pristine beaches of San Salvador. Once again, the Indians hide in the bushes.

Now of course you know where Columbus actually landed! Don't you?

That's right. He was in America!
From *The Value of Curiosity*

It is 1977. *The Value of Curiosity* continues a tradition that trivializes or effaces the death, destruction, and resistance of the indigenous inhabitants of the Americas. Once again, providentially sanctioned Europeans are depicted disembarking on the sunlit shores of a prostrated people about to receive the benefits of a obviously rational, obviously enlightened, and obviously superior civilization.

It is 1991. According to General Mills, Columbus celebrated his discovery of America with a bowl of Honey Nut Cheerios: "The golden honey and crunch nut taste was [his] best discovery of all."

It is 1991. I pledge allegiance to the flag of the **U**rine-tested **S**tates of a drug-free **A**merica. On the eve of the quincentenary, Great White Father George Bush and his corporate sponsors are busily orchestrating the continuous carpet-bombing of the American mind. In their heroic delirium, they insist that there will be liberty and justice and a **New • World • Order** for all . . .

a•mer•i•ca is reality.

A SELECT BIBLIOGRAPHY

ANDERSON, Arthur, and Charles Dribble, trans. *The War of Conquest: The Aztecs' Own Story As Given to Friar Bernando Sahagún.* Salt Lake City: University of Utah Press, 1978.

ARENS, W. *The Man-Eating Myth.* New York: Oxford University Press, 1978.

AXTELL, James. *After Columbus.* New York: Oxford University Press, 1988.

BAIGELL, Matthew. *Albert Bierstadt.* New York: Watson-Guptill Publications, 1988.

BARREIRO, José. "Indians in Cuba," *Cultural Survival Quarterly* 13 (3): 57-60.

BELFRAGE, Cedric. *My Master, Columbus.* London: Secker & Warburg, 1961.

BERKHOFER, Robert F., Jr. *The White Man's Indian.* New York: Vintage, 1978.

——. *The Book of Chilam Balam of Chumayel.* Norman: University of Oklahoma Press, 1967.

BORAH, Woodrow, and Sherburne F. Cook. *Essays in Population History: Mexico and the Caribbean.* Berkeley: University of California Press, 1971. Vol. I.

BUCHER, Bernadette. *Icon and Conquest.* Trans. Basia Miller Gulati. Chicago: University of Chicago Press, 1981.

CHIAPELLI, Fredi, ed. *First Images of America.* Berkeley: University of California Press, 1976. Vol. I.

COHEN, J.M., ed. and trans. *The Four Voyages of Columbus.* New York: Penguin, 1969.

CROSBY, Alfred W. *The Columbian Exchange: Biological and Cultural Consequences of 1492.* Westport, CT: Greenwood Press, 1973.

——. *Ecological Imperialism: The Biological Expansion of Europe, 900-1900.* New York: Cambridge University Press, 1986.

DIAZ del Castillo, Bernal. *The Conquest of New Spain.* Trans. J. M. Cohen. New York: Penguin, 1963.

DICKASON, Olive. *The Myth of the Savage.* Alberta: University of Alberta Press, 1984.

DRINNON, Richard. *Facing West: The Metaphysics of Indian-Hating and Empire-Building.* New York: Pantheon, 1990.

GALEANO, Eduardo. *Memory of Fire/Genesis.* Trans. Cedric Belfrage. New York: Pantheon, 1985.

GERBI, Antonello. *Nature in the New World.* Pittsburgh, PA: University of Pittsburgh Press, 1975.

GIARDINI, Césare. *The Life and Times of Columbus.* Trans. Frances Lanza. London: Paul Hamlyn, 1967.

GIBSON, Charles, ed. *The Black Legend.* New York: Knopf, 1971.

GRANZOTTO, Gianni. *Christopher Columbus.* Norman, OK: University of Oklahoma Press, 1984.

HANKE, Lewis. *Aristotle and the American Indian.* Bloomington, IN: Indiana University Press, 1959.

——. *Bartolomé de Las Casas, Historian.* Gainesville, FL: University of Florida Press, 1952.

HENRY, Jeannette. *Textbooks and the American Indian.* N.P.: Indian Historian, 1970.

HONOUR, Hugh. *The European Vision of America.* Cleveland: Kent State University Press, 1975.

——. *The New Golden Land.* London: Penguin, 1975.

JENNINGS, Francis. *The Invasion of America.* New York: Norton, 1975.

JOHNSON, Spencer. *The Value of Curiosity: The Story of Christopher Columbus.* La Jolla, CA: Value Communications, 1971.

KONING, Hans. *Columbus: His Enterprise.* Rev. ed., New York: Monthly Review Press, 1991.

LAS CASAS, Bartolomé de. *The Devastation of the Indies.* Trans. Herma Briffault. New York: Seabury, 1974.

———. *History of the Indies.* Trans. and ed. Andrée Collard. New York: Harper & Row, 1971.

LEON-PORTILLA, Miguel. *Pre-Columbian Literatures of Mexico.* Trans. Grace Lobanov and the author. Norman, OK: University of Oklahoma Press, 1969.

LUCOT, Manuel Bendala. *Seville.* Trans. Diorki—Madrid. León, Spain: Editorial Everest, 1970.

MORISON, Samuel Eliot. *Christopher Columbus, Mariner.* New York: Meridan, 1942.

OLSEN, Fred. *On the Trail of the Arawaks.* Norman, OK: University of Oklahoma Press, 1974.

PEARCE, Roy Harvey. *Savagism and Civilization.* Rev. ed., Baltimore: Johns Hopkins University Press, 1965.

PIZAN, Christine de. *The Book of the City of Ladies.* Trans. Earl Jeffrey Richards. New York: Persea Books, 1982.

RETAMAR, Roberto Fernández. *Caliban and Other Essays.* Trans. Edward Baker. Minneapolis: University of Minnesota Press, 1989.

ROSENSTIEL, Annette. *Red and White.* New York: Universe, 1983.

SALE, Kirkpatrick. *The Conquest of Paradise.* New York: Knopf, 1990.

SANDERLIN, George, trans. and ed. *Bartolomé de Las Casas: A Selection of His Writings.* New York: Knopf, 1971.

SAUER, Carl Ortwin. *The Early Spanish Main.* Berkeley: University of California Press, 1966.

SHEEHAN, Bernard. *Savagism and Civility.* New York: Cambridge University Press, 1980.

SLOTKIN, Richard. *Regeneration Through Violence: The Mythology of the American Frontier, 1600-1860.* Middletown, CT: Wesleyan University Press, 1973.

STEDMAN, Raymond Williams. *Shadows of the Indians.* Norman, OK: University of Oklahoma Press, 1982.

TIFFANY, Sharon W., and Kathleen J. Adams. *The Wild Woman: An Inquiry into the Anthropology of an Idea.* Cambridge, MA: Schenkman Publishing Company, Inc., 1985.

TODOROV, Tzvetan. *The Conquest of America.* Trans. Richard Howard. New York: Harper and Row, 1984.

TURNER, Frederick. *Beyond Geography.* New York: Viking, 1980.

VARNER, John, and Jeannette Varner. *Dogs of the Conquest.* Norman, OK: University of Oklahoma Press, 1983.

WAGNER, Henry R. *The Life and Writings of Bartolomé de Las Casas.* Albuquerque, NM: University of New Mexico Press, 1967.

WEATHERFORD, Jack. *Indian Givers.* New York: Crown, 1988.

WHITE, Hayden. *Tropics of Discourse.* Baltimore: Johns Hopkins University Press, 1978.

ZINN, Howard. *A People's History of the United States.* New York: Harper & Row, 1980.